CONTINENTAL PORCELAIN

To my grandson, Dominic Arnell

CONTINENTAL PORCELAIN

John Cushion

Former Senior Research Assistant
Department of Ceramics
Victoria and Albert Museum, London

Charles Letts Books Limited

The author wishes to express his thanks to the following owners of the porcelain illustrated in this book. Constance and Anthony Chiswell Antiques Ltd, Hoff Antiques Ltd, The National Trust (Gubbay Collection, Clandon Park) and The Victoria and Albert Museum.

First published 1974
Revised edition 1982
by Charles Letts Books Limited
77 Borough Road, London SE1 1DW

Photographs: Michael Dyer Associates

ISBN 0 85097 354 6

Printed and bound by Charles Letts (Scotland) Ltd

CONTENTS

INTRODUCTION

The Introduction of Porcelain to Europe

The Chinese potters had been producing a hard-paste porcelain for over four hundred years before knowledge concerning its manufacture reached Europe. This information was acquired by Marco Polo, who, upon his return to Venice from the court of Khublai Khan, at the end of the 12th century, almost certainly brought with him some examples of this new and exciting material, which he termed 'pourcelaine', which at that time meant sea-shells or mother-of-pearl.

The Far Eastern potter had been acquainted with kaolin, or china-clay, since the Han dynasty (206BC—AD 220) but it was nearer AD 850 before the second necessary ingredient of china-stone (petuntse) was discovered. These two forms of granite in varying stages of decomposition, were fired at a temperature of about 1350°C, to form a hard white translucent body. These materials were appropriately described by the Chinese as the flesh and the skeleton of porcelain; the white particles of the china-clay forming a base for the translucent china-stone. The glaze of true porcelain is composed basically of the china-stone, and in consequence can be fired at the same time as the body. This glaze fits the body well and rarely 'pools', gathers in tears or crazes (minute crackling of the glaze).

Early Italian Porcelain

From the second half of the 15th century Chinese porcelain was reaching Italy in large quantities through her trade with the Near Eastern countries of Egypt, Syria and Turkey but, from the 14th century, Italian potters had been engaged in producing maiolica, a biscuit-coloured earthenware with an opaque white glaze (tin-glazed earthenware). In addition they were making a fine quality glass, decorated with enamel colours. Knowledge of these two materials was to be combined to result in an early form of imitation, or soft-paste porcelain. Experiments were taking place from the beginning of the 16th century but these consisted primarily of opacifying glass. A soft-paste porcelain which included clay was not manufactured until about 1575, at the Florentine court of Francesco I de'Medici.

This so-called Medici porcelain was composed of about 80% white clay, and 20% the materials of glass. Records prove that at least some of these early porcelains were fired by Flaminio Fontana, a maiolica potter from Urbino, who was in Florence from 1573. There are about sixty examples of this manufacture on record today, and they are nearly all of simple European form, with painted decoration in underglaze blue (cobalt), sometimes with purple outlines (manganese). These two colours are termed 'high-temperature' colours, meaning they can be fired at the same temperature necessary to fire the glaze. Whilst underglaze blue was used by the Chinese to decorate their porcelain from about AD 1300,

manganese can only be used as an underglaze colour on the lower-fired soft-paste.

Later Italian Porcelain

The first true porcelain to be made in Italy was produced at Venice between 1720 and 1727 by Francesco Vezzi (1651–1740) but very little credit is due to this wealthy goldsmith, who merely purchased the knowledge of the manufacture from a renegade Meissen workman, and acquired his clays from Saxony. It was probably due to a ban on the export of these materials that Vezzi's factory was brought to a halt in 1727.

These early Venetian porcelains showed very little originality, most of their styles being derived from the earlier factories of Meissen and Vienna. Teapots seem to have been their speciality, and a few very characteristic teapots of octagonal form, with high relief acanthus leaves, are among their most attractive wares.

The porcelains produced at Venice from 1764 by Geminiano Cozzi are more frequently encountered than those of Vezzi. The material was very inferior to the earlier production and usually of a grey hue. Their palette of enamel colours had a lot in common with other contemporary Italian porcelain factories, and invariably included the typical brownish-reds, purples, blues and a poor yellowish-green.

The much more successful factory of Doccia, near Florence, was established in about 1737 by the Marchese Carlo Ginori of Florence. Their early material is usually considered a hybrid, rather than a true hard-paste. It has a similar grey tone to the later Cozzi porcelain, and was at times completely covered with a white opaque glaze (as if a tin-glazed earthenware). From 1757 the factory was under the direction of Lorenzo Ginori, who was responsible for introducing many new shapes in an improved paste, and of much finer potting.

Doccia was the factory where plaques, boxes and useful wares 'with figure subjects in low relief' were first introduced. This is the style of decoration which for many years has wrongly been associated with the soft-paste porcelain factory of Capodimonte. It was during the second half of the 19th century that the crowned 'N' of the Royal Factory of Naples was used as a mark on some of these relief decorated wares made at the Doccia factory. Despite their late date, these falsely marked pieces are rare, and the majority of hard-paste porcelain wares and figures bearing a crowned 'N' mark 'that are met with today, are the work of such German factories as that of Ernst Bohne, whose manufactory at Rudolstadt in Thuringia, was not established until 1854.

True Capodimonte is almost certainly some of the rarest, and most expensive European porcelain to acquire. The factory was started by Charles of Bourbon, King of Naples and Sicily, in the grounds of the Capodimonte Palace in 1743, where production continued until 1759, when Charles succeeded to the throne of Spain. The manufactory was then moved to the grounds of the Buen Retiro Palace near Madrid.

The soft-paste porcelain of Capodimonte was a beautiful material,

very white and highly translucent. The glaze fitted well and at times had a matt finish, which was an ideal surface for the pale enamels used. Tea-services, snuff-boxes, cane-handles and vases were among their most popular useful wares, but the true beauty of Capodimonte is best seen on the groups modelled by Gricc, whose figures can often be recognised by their very small heads.

After the supplies of the clays taken from Italy to Spain at the time of the transfer were exhausted, the wares and figures produced at Buen Retiro were made of a rather inferior soft-paste, often decorated in loud garish colours, somewhat in the manner of late-18th-century Staffordshire figures in England. The Buen Retiro factory was eventually destroyed by the British military forces in 1812.

The Royal Factory of Naples was established in 1771 by Ferdinand IV, son of Charles III. The early soft-paste porcelain made here was of a rather creamy colour ideal for the many neo-classical wares they produced, inspired, of course, by the excavations that had been taking place, over many years, at Herculaneum and Pompeii.

Among the other porcelain factories established in Italy during the second half of the 18th century were those of Este, Treviso, Turin, Vische, Vinovo and Le Nove. With the exception of the latter, wares produced at these minor concerns are rarely seen outside of museums and private Continental collections. Pasquale Antonibon succeeded in producing a good quality hard-paste at Le Nove by about 1762, but ill health prevented him continuing the production and it was from 1781, when the factory was under the direction of Francesco Parolin, that good quality wares were regularly produced, sometimes decorated by the talented painter Giovanni Marconi, who often signed his work. The porcelain concern closed in 1825, but many comparatively modern tin-glazed wares are to be seen today with Le Nove marks.

Meissen and German Porcelain factories

Before the early-18th century, the only true porcelain throughout the civilised world was that produced in China, and from at least the middle of the 16th century large sums of money were spent by the European courts on the purchase of this material. When Augustus II, King of Poland, succeeded to the title of Elector of Saxony in 1694, he requested his economic adviser, Count von Tschirnhaus (d.1708), to organise a survey into the mineral wealth of the country, with the aim of locating the materials necessary for the manufacture of hard-paste porcelain, akin to that of the Far East, and also the ingredients required to produce a high quality glass which would match that of Bohemia.

Throughout the first decade of the 18th century, Tschirnhaus and his assistant, J. F. Böttger (d.1719), who was a talented young alchemist, carried out many experiments, but it was not until 1710, two years after the death of Tschirnhaus, that sufficient success had been achieved to warrant the establishment of the Royal Saxon Porcelain Manufactory. The earliest Meissen porcelain did not include the material of china-stone, and alabaster was used as an alternative, resulting in a rather ivory-toned

material, but by about 1718 the correct material had been located, and the resultant porcelain was even whiter than that of China. At Meissen the proportion of china-clay (kaolin) was greater, and the firing temperature higher (1400°C.).

It was only from about 1720 that Meissen porcelain began to be decorated with the fine enamel painting which often surpassed that seen on the contemporary Chinese porcelains. These colours were introduced by the famous Meissen decorator, J. G. Herold, who was persuaded to leave the Vienna factory of Du Paquier by the renegade Meissen kiln-master, Stölzel. During the 1720s the majority of Meissen table-wares were of comparatively simple form, which gave Herold ample scope for his beautiful chinoiseries, stylised flower-painting and harbour-scenes but, from 1731, when the modeller Kaendler was first engaged, Herold was faced with very real competition.

Before he began producing his famous figures, Kaendler was engaged in helping to model large table-services, such as that made for Count Sulkowski, and the even better known Swan Service of 1737, made for Count Brühl, who had been appointed as Director of the factory, following the death of Augustus II in 1733. From about 1738 Kaendler was engaged in creating the profusion of miniature figures, which were to replace the sugar and ice confections, which had formerly been used to decorate the tables at the lavish banquets of the Court of Dresden. By the mid-18th century the Meissen factory was employing over five hundred workers and exporting large quantities of porcelain to Russia, Turkey, Poland, France and England, but this period of prosperity was brought to a close when the state of Saxony became involved in the Seven Years War (1756–63), and the factory was occupied by the troops of Frederick the Great of Prussia, a disaster from which it never really recovered. The factory was moved from Albrechtsburg, in 1864, to a new building, erected by the state, at Triebischtal, near Meissen, and production of many of their early models is still continued to this day. Their modern wares are still marked with the original crossed-swords factory-mark, as adopted in 1723, but now usually accompanied with the word 'GERMANY', and are made from a very grey porcelain.

The factory at Vienna, first established by Du Paquier in 1717, enjoyed little success until 1719, when the owner was joined for a short period by the Meissen kiln-master, Stölzel. Even when manufacturing good porcelain at full production, however, this Viennese factory offered very little competition to the wares made at the state subsidised factory at Meissen. In 1744 Du Paquier was in such financial difficulties that he was forced to sell his undertaking to the Austrian Empress, Maria Theresa. The factory was then run by the state until 1784, when it was put in the charge of a very successful wool-merchant, Konrad von Sorgenthal. The original concern eventually closed in 1866 and those poor quality porcelains seen for sale to-day, with the two-bar shield mark of Austria, are later German or Austrian reproductions, the decoration usually consisting of transfer-prints.

As the middle years of the 18th century were reached, more workmen who had acquired knowledge of the manufacture of hard-paste porcelain from Meissen, became prepared to sell this information to the highest bidder, with the result that porcelain manufactories soon appeared in many other German states, usually subsidised by the head of that state. Fortunately, it has always been the practice in Germany for the majority of at least the major concerns to adopt factory marks, which they have applied fairly consistently. Without the help of these underglaze-blue devices, it would certainly be very difficult to attribute the majority of their table-wares. The most important of these factories were at Höchst (1750), Fürstenberg (1753), Berlin (1751, the present day State Factory was not established until 1763), Nymphenburg (1753), Frankenthal (1755), and Ludwigsburg (1758). At this same period many minor factories were started in the forest region of Thuringia, and many unmarked wares of late-18th- and 19th-century styles must be vaguely attributed to this 'Staffordshire' of Germany.

The Porcelains of Holland

The fact that the Dutch East India Company monopolised the trade with China during the whole of the 17th century, seems only to have affected the styles of their well-known tin-glazed earthenware (Delftware), and the familiarity of the Dutch with Chinese porcelain appears to have had no influence whatever on their own porcelains made at the factories at Weesp, Oude Loosdrecht, Amstel and The Hague. The outstanding difference between the German porcelain factories and those of Holland was that the latter were entirely commercial concerns, and in no way subsidised by the state or wealthy patrons.

The earliest Dutch factory at Weesp was producing a hard-paste porcelain from about 1762, continuing until 1771, when it was purchased by Johannes de Mol, who transferred the concern to Oude Loosdrecht, near Hilversum. Their productions were technically of a high quality, but were very dull and of unoriginal form, usually following the current German fashions. Production continued at Oude Loosdrecht, but the moulds transferred from Weesp were soon discarded in favour of the newer French forms of the so-called *Louis-Seize* styles. These were sometimes decorated with very attractive landscapes in sombre toned enamel colours. In 1784 this undertaking was again transferred, this time to Oude Amstel, near Amsterdam, where production continued until 1820. For the last eleven years the factory operated under G. Dommer & Co. at Nieuwer Amstel. Very few new designs were made here, other than table-wares in the current fashions of Paris porcelain.

Porcelain bearing the mark of a stork with an eel in its mouth can be a little confusing, for many of these pieces were made at Continental factories outside of Holland, and only decorated at the workshop of Anton Lyncker, which he started in about 1773. These pieces usually bear the original factory-mark in underglaze-blue, with The Hague mark superimposed in blue enamel. From about 1776 Lyncker started a manufactory for hard-paste porcelain, which was continued by his

widow from 1781–90. The Hague porcelain certainly showed more originality than the earlier Dutch factories, and produced some excellent tablewares in the neo-classical taste of the period.

Scandinavian Porcelain

The potters of the Scandinavian countries were seemingly content for many years to concentrate on the production of tin-glazed earthenware (faience), and it was 1759 before a short-lived soft-paste porcelain manufactory was started in Copenhagen by Louis Fournier, a Frenchman who had previously been employed at Vincennes and Chantilly. Fournier's production lasted from 1759 until 1765, during which time it was patronised by King Frederick V. Their modest tablewares made during these years were of a slightly yellowish material, with a dull glaze, and usually decorated in contemporary French styles, in a palette of rather pale colours.

It was 1771 before F. H. Muller put to use the necessary clays for the manufacture of a hard-paste porcelain, which had been located as early as 1755 on the island of Bornholm. This factory was taken over by the King in 1779, and continues to the present day as the Royal Copenhagen Porcelain Company. Due to the influence of workmen from the German factory of Fürstenberg there was, at first, a marked similarity between the wares of both factories; but, from 1779, the shapes became extremely neo-classical, rather suggesting Josiah Wedgwood's stoneware forms, but cluttered with rather ill-fitting relief garlands, swags, and painted silhouettes, etc. Some attractive biscuit porcelain plaques were produced from about 1867, however, often inspired by the work of the famous Danish sculptor, Bertel Thorwaldsen (d.1844).

A very pleasing soft-paste porcelain was also made by Pierre Berthevin, from 1766, at Marieberg in Sweden. Berthevin had previously worked at the French factory of Mennecy and there is a marked similarity between the wares made at both factories, until at least 1769. In 1769 Berthevin was succeeded by Henrik Sten, whose porcelain was a rather unpleasant chalky material until 1777, when he began to make a true hard-paste.

Russian Porcelain

Although efforts were made to organise a factory for the manufacture of porcelain in St. Petersburg, Russia, from as early as 1718, it was about the middle of the 18th century before Dmitri Vinogradov was successful in producing wares of a very fine hard-paste porcelain, which were at the time considered to rival those of the long-established factory at Meissen.

The Imperial State Porcelain Factory produced some very beautifully decorated table-wares and charming figures, many of the lavishly decorated services being specially ordered by the Empress Catherine II, to be given by her as gifts to her many court favourites. Porcelain became so popular in Russia from about 1760, that other firms were encouraged by the court to start production. One of the first of these independent ventures was begun in Moscow in 1766, by Yakovlevich Gardner, whose family continued to make good quality table-wares, and doll-like figures,

until being taken over by the rival firm of Kutnetsov in 1892. Among the other Russian porcelain undertakings which produced wares sought by today's collectors, were the Kievo-Mezhigorskaya Fabrika, established at Kiev in 1798, Carl Melli's concern at Gorbunov, near Moscow, 1811, the factory of N. S. Kudinov at Lystsovo, near Moscow, operating from 1818, and that of the Prince Nikolay Borosovich Yusupov, at Archangel'skoe from 1814.

Early French Porcelain

With the exception of the rare specimens of soft-paste porcelain made in Florence during the last quarter of the 16th century, there would not appear to have been any serious attempts to produce a similar material until Louis Poterat, a French earthenware potter of Rouen, was granted a patent for the manufacture of porcelain in 1673. Poterat seemingly made little use of his licence to manufacture 'porcelains and pottery in the fashion of Holland' before he died in 1696, and there still remains a great deal of doubt as to the authenticity of the few minor table-wares that are attributed to him. These pieces are all decorated in underglaze-blue in the popular *lambrequin* style, as used on so much Rouen faience (French tin-glazed earthenware); a fashion invented by the court designer Bérain, and obviously inspired by Chinese blue and white porcelain.

Knowledge concerning the soft-paste porcelain made at Saint-Cloud by the Chicaneau family is based on much surer evidence. Soft-paste porcelain was made at this factory from about 1693 until 1766. The factory enjoyed the 'protection' of Monsieur, brother of Louis XIV, who in 1702 granted letters patent to the widow of Pierre Chicaneau, who had married the potter Henri Trou. After the death of the founder's widow in 1722, the factory passed into the hands of Henri and Gabriel Trou; now with the added protection of the Duke of Orleans.

There is a great similarity between the porcelains of Saint-Cloud and those of the early English factory at Chelsea. The wares tended to be small and thickly potted, obviously with the intention of minimising the risk of warping during firing. This porcelain was particularly suitable for reproducing the hard-paste porcelain wares of China; referred to as *blanc-de-Chine*, which were at that time being imported into Europe from the Fukien province.

A further early, important, French soft-paste porcelain factory was established at Chantilly in 1725 by Ciquaire Cirou, under the patronage of Louis-Henri, Prince de Condé. The Prince possessed a very large collection of Japanese porcelain, which, at that time, was thought to have been manufactured in Korea, giving rise to the term *décor Coréen*. These porcelains were usually decorated in the so-called Kakiemon styles and, in order to make their creamy soft-paste more suitable for such decoration, the Chantilly potters covered their wares with a white opaque glaze. Wares of this type were produced at Chantilly until about 1740, when the Prince died. During these early years Japanese type decoration was often applied to many European shaped pieces, inspired by contemporary Meissen or silver shapes.

From the middle of the 18th century a normal transparent lead-glaze was used, with either enamel naturalistic flowers, or underglaze-blue painting, which often consisted of the well-known 'Chantilly sprig' pattern, with a basket-work moulded border. Although the original factory closed *c.*1800, other minor concerns continued well into the 19th century, making similarly decorated pieces in a hard-paste porcelain.

Probably the finest of all early French soft-paste porcelains were those made at the manufactory referred to as Mennecy, despite the factory having started first in Paris, where it remained until 1748, when the undertaking was moved to Mennecy. Production continued at Mennecy until 1773, when a further move took place, this time to Bourg-la-Reine where the factory continued until the final closure in 1806.

The material used at Mennecy was milky-white, with a 'wet' and brilliant glaze, which absorbed their versions of naturalistic German flower-painting in a manner which provides what is probably the best illustration of this peculiarity of a good soft-paste porcelain. Due to various monopolies enforced at that time in favour of Vincennes and Sèvres, the decorators of Mennecy were prevented from using gilding, and lined their table-wares with a pleasing deep rose pink enamel.

The Porcelains of Vincennes and Sèvres

The Meissen factory must be considered as the fashion-setter for European porcelain during the first half of the 18th century, the Baroque period. The Seven Years War, when the factory was occupied by the troops of Frederick the Great of Prussia, virtually brought production to a standstill, and by the time the war had ceased in 1763, Meissen's leadership in the world of porcelain had been taken over by Vincennes and Sèvres, whose wares were to excel in the spirit of rococo.

Experiments concerned with the manufacture of a soft-paste porcelain were started in a disused royal château at Vincennes, near Paris, as early as 1738, by Orry de Fulvy, with the assistance of Gilles and Robert Dubois. These two brothers, who had previously been employed at the Chantilly concern, proved to be very ill informed as to the manufacture, and they were replaced with the more knowledgeable potter François Gravant, who had also worked at Chantilly. It was nearer 1745 before a new company was formed and a really successful manufacture was achieved, financed in part by King Louis XV. By 1753 the Vincennes building was proving inadequate for the *Manufacture royale de porcelaine*, and work was started on a new building at Sèvres, close to Madame de Pompadour's château at Bellevue. The King's mistress took a great interest in the welfare of the Royal factory, and it was almost certainly due to her that the factory was bought by the King, when faced with financial difficulties and possible closure in 1759.

The Royal cipher of crossed 'L's was adopted as a factory mark from about 1738, and from 1753 a system of year-dating was adopted. This consisted of a letter within the double 'L' device, 'A' indicated 1753, 'B', 1754, and so through the alphabet, and into double letters ('AA', 'BB', etc.) until 1793, when the factory was taken over by the French

Republic. Unlike Meissen, the Sèvres marks are particularly helpful and the painters and gilders also applied their marks to the majority of the wares made after the move to Sèvres. The names of these workers and the devices, or initials, used, are nearly all recorded and it is known during which years they were employed, and the type of decoration they specialised in. This knowledge can usually be used to decide whether an example is genuine, has been decorated at a later date, or is a complete 19th-century reproduction. For example we know that the materials for the manufacture of true porcelain were not generally used at Sèvres until about 1769, and thus any wares bearing a year-mark prior to this date should be of a soft-paste porcelain (1769 = date letter Q).

Probably the best known example of early Vincennes porcelain was the huge bouquet of porcelain flowers, sent by the Dauphine Marie-Josephe to her father, Augustus III of Saxony. This gift consisted of four-hundred and eighty naturalistically coloured blooms in a white porcelain vase, which was itself decorated with sprays of white flowers in high relief. The vase is flanked by a pair of white-glazed porcelain figures, symbolic of the Arts, the whole being mounted on a base of gilt bronze (*ormolu*) designed by Duplessis. The entire group is $45\frac{1}{2}$ inches (115 cm) high and is to be seen at Der Zwinger, in Dresden.

Porcelain figures as decoration for the banqueting table were apparently less popular in France than in the courts of other European states, and, apart from a few interesting and unique examples, most early Vincennes and Sèvres figures were left in the unglazed state (biscuit), with the intention of imitating marble figures. Those conversant with the French language are often baffled as to why the term 'biscuit' should be used to indicate a ware which has been once fired, instead of the more logical twice, but the jargon of ceramics now includes many nonsensical terms, which probably made better sense when first introduced.

After the move from Vincennes to Sèvres, their porcelains might well be criticised as being too heavily decorated, so much so that at times it is no longer readily apparent that the ware is of porcelain. Despite this fault, their ground colours and the work of some of their most skilled painters, is of outstanding beauty. (The introduction of the various grounds and the work of some of the better-known painters, is discussed in the text alongside the appropriate illustration.)

Up until about 1769 all Vincennes and Sèvres porcelain was of a soft-paste. The ingredients of true porcelain were located in 1769 at Saint-Yrieix, near Limoges, but it was at least three years before the new material was used to any degree. Soft-paste continued to be produced, together with the hard, up until 1804, when it was finally abandoned.

It is regrettable that the authorities in charge of the manufactory after the overthrow of the monarchy decided to sell off large quantities of earlier faulty, or outmoded, undecorated wares, for these are often the pieces which today cause so much confusion for dealer and collector alike. These were the pieces of genuine early porcelain which have often been decorated in the late-18th, or early-19th century, in the most costly

and sought-after styles, usually with a completely false factory-mark, invariably suggesting a very early date. These pieces can often be faulted on the poor quality of the gilt decoration, or the presence of minute 'black-heads', a sign often seen on soft-paste porcelain which has been re-fired long after the original manufacture. This same fault can sometimes be seen on wares which have been repaired with the use of excessive heat.

Later Porcelain Factories of France

The earliest hard-paste porcelain to be made in France was that produced by Paul Hannong at Strasbourg from about 1752–55, prior to his being compelled by the Vincennes authorities to move his production out of France to Frankenthal, where he established a hard-paste porcelain factory under the patronage of the Elector Carl Theodor.

The majority of French hard-paste porcelain available to the present day collector was made in the numerous small concerns which were established in the area of Paris from about 1770. These factories usually survived despite the privileges enjoyed by the King's factory, simply because they too were protected by a member of the Royal family.

The factory of Clignacourt (1771–c.1798) was associated with Monsieur le Comte de Provence, brother of Louis XVI, who was eventually to succeed to the throne himself, in 1814, as Louis XVIII. The factory of Rue Thiroux (1775–c.1870) was initally protected by the unfortunate Queen Marie Antoinette, but was continued later by various other owners. The factory of Rue de Bondy was established in 1780 under the patronage of the Duc d'Angoulême, whose name is still used to describe the attractive pattern of enamelled sprigs of cornflowers, which was also imitated at many other French and English factories.

New collectors are sometimes puzzled over the term 'Limoges'. There was an early factory established in this area under the patronage of the Comte d'Artois in 1771. This concern was taken over by the King in 1784, and finally closed in 1796. The entire area of Limoges can best be likened to the English area of Staffordshire. It is the centre of the French ceramic industry, the factories tending to congregate throughout the 19th century in the area where the necessary raw materials were available. The collector is reminded that the mark, or initials, of a factory, together with 'LIMOGES' and 'FRANCE', indicate a date after 1891, when the American McKinley Tariff Act was introduced, and all wares imported in-to the U.S.A. were required to bear the name of the manufacturing country.

Wrong attributions are often made regarding some very confusing wares made in the so-called Rockingham style. These wares, which have the appearance of the revived-rococo style, as used at several English factories from about 1825–40, are often found to be of French hard-paste porcelain, which is very white and glassy. These French examples are sometimes marked with an underglaze-blue 'J.P', the initials of Jacob Petit, who was working at Fontainebleau at about that period. Other misleading wares are those pieces of hard-paste French porcelain which were decorated in London in the Swansea or Coalport fashions during the early decades of the 19th century.

Plate 1

Teapot; hard-paste porcelain,
painted with enamel colours
Mark: crossed swords in blue
enamel
MEISSEN (Saxony); 1723–30
Height 5¼ ins.

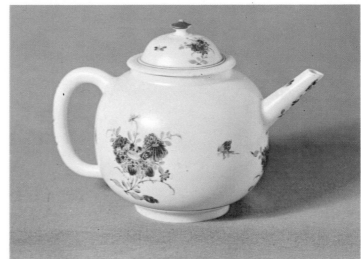

Hoff Antiques Ltd.

The earliest wares produced by Tschirnhaus and Böttger at Meissen were
of a fine red stoneware (*Jaspis porzellan*) similar to the red I-hsing
stoneware of China, but harder and of a much finer grain. This red
stoneware was produced from about 1708 until at least 1730. The
material was so hard that a glaze-like finish was frequently obtained by
polishing on a wheel, as if polishing a hard stone.

The Royal Saxon Porcelain Manufactory was officially established in
the Albrechtsburg fortress at Meissen from March 7th, 1710. Their
earliest white porcelain consisted of china-clay with alabaster, the correct
material of china-stone not being used until nearer 1720. Many of
Böttger's early forms were taken directly from Chinese originals, but the
early applied decoration usually consisted of sprays of rose or vine, in
preference to the more customary Oriental prunus.

Due to the necessary high-firing temperatures to fuse the enamel
colours to the very hard glaze, the attempts made prior to Böttger's death
on March 13th, 1719, were not very successful. The painting on this
teapot is based on the early Chinese style of flower painting in the palette
of the so-called *famille rose* (including the colours of pinks to deep
crimsons, derived from chloride of gold), a style referred to at Meissen as
the *indianische Blumen*.

Plate 2

Box and cover; hard-paste
porcelain, painted in enamel colours
Mark: crossed swords in blue
enamel
MEISSEN (Saxony); 1725–30
Diameter 4½ ins.

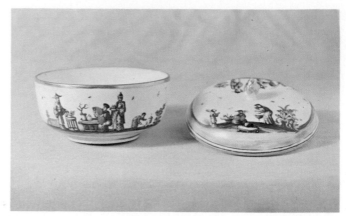

Hoff Antiques Ltd.

Samuel Stölzel, the Meissen kiln-master, deserted to the Vienna factory
in 1719, but he returned within the year, accompanied by the twenty-
four-year-old painter, Johann Gregor Herold (or Höroldt), who had
previously been engaged in decorating porcelain for du Paquier at
Vienna.

From 1720 to about 1730 Meissen was virtually the only porcelain
factory of any account in Europe and it was during this period that so
many of their wares were so finely decorated in the various styles
introduced by Herold. Among the most popular of his early works were
the chinoiseries, delightful little 'fairyland fantasies' based on the
contemporary beliefs concerning life in the very remote country of
China. These were in no way connected with the Meissen reproductions
of earlier Far Eastern porcelain. Similar chinoiserie designs to that shown
on the box and cover were in many instances based on earlier engravings
by such artists as Gillot and Watteau.

Plate 3

Dish; hard-paste porcelain, with
moulded decoration and enamel
colours
MEISSEN (Saxony); c.1735
Diameter $9\frac{1}{4}$ ins.

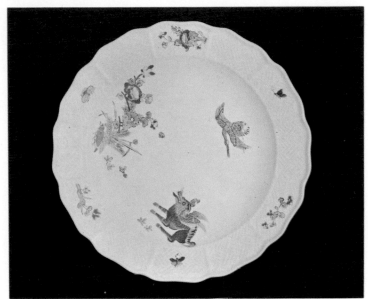

Hoff Antiques Ltd.

It was not until 1727 that the young sculptor J. G. Kirchner (b.1706) was
specially appointed as a modeller for the production of figures at the
Meissen factory, but after a year he was dismissed for being 'frivolous and
disorderly'. His successor J. C. L. von Lücke, who was a fine ivory
carver, proved to be unable to adapt his skill to the production of the
type of wares demanded by Augustus, and so remained at the factory for
only a very short period. In 1730 Kirchner was re-appointed, and
seemingly concentrated on the large vases and figures demanded by the
King to furnish his Japanese Palace.

J. J. Kaendler, who was the same age as Kirchner, was appointed by
Augustus to assist Kirchner in 1731 and his work was considered to be so
superior that, in 1733, Kirchner was finally dismissed. Kaendler's early
years here appear to have been devoted to making large table-services
with high relief modelling, rather than to individual figures or groups.
Upon the death of Augustus the Strong in 1733, his son Frederick
Augustus appointed his minister, Count von Brühl, factory director, a
post Brühl retained until his death in 1763.

This dish shows the pleasing combination of the skills of both J. G.
Herold and Kaendler. The plate is moulded in the popular *ordinair ozier*,
the simple basket-work pattern introduced by Kaendler and used on the
famous service made, between 1735 and 1737, for Count Sulkowsky, a
court favourite of Augustus III. The decoration in enamel colours is one
of the many versions of the popular Kakiemon, a style of painting used
on the fine Japanese porcelain made at Arita from the late years of the
17th century and, in this instance, referred to as 'the flying dog' or 'fox'.

19

Plate 4

Tea-caddy; hard-paste porcelain,
painted in enamel colours
Mark: Gilder's mark
MEISSEN (Saxony); c.1738
Height 4 ins.

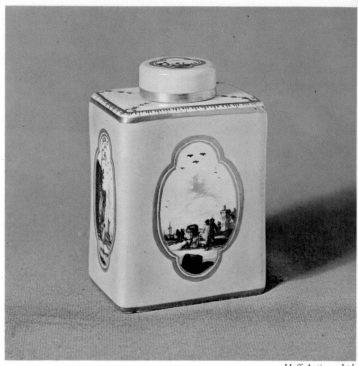

Hoff Antiques Ltd.

It was not until the 1730s that more frequent use was made of European
landscapes as a form of decoration. Many of these paintings took the
form of busy little harbour scenes, most probably inspired by the late-
17th-century Augsburg engravings of Italian ports by Melchior Kysell,
after the paintings of J. W. Baur. Decoration in this manner is often
attributed to J. G. Heintze, reputedly one of Herold's most talented
painters. However, the name is best used to indicate the style, rather than
to suggest the work of the individual. Similar paintings of harbour scenes
are considered to be by Christian Friedrich Herold, a kinsman of J. G.
Herold. These same scenes were at times copied from Meissen porcelain
on to the porcelain made at Chelsea during the 'red anchor' period
(1752–8).

From as early as 1725 Herold began to produce the first of the many
coloured enamel grounds used to decorate their wares. The earliest of
these colours were the 'Imperial' yellow, powdered blue (underglaze-
blue applied in a powder form), and 'dead-leaf' brown. Slightly later
ground colours included various shades of emerald green, sea green, lilac,
deep purple and a pale blue, as illustrated. The recognised factory-mark,
of crossed swords in underglaze-blue, appears to have been used
consistently from 1723, but when it was applied directly on to the biscuit
(unglazed body), it was inclined to burn away and become indistinct.

Plate 5

Box and cover; hard-paste
porcelain, painted in enamel colours
Mark: crossed swords in
underglaze-blue
MEISSEN (Saxony); *c*.1740
Diameter $2\frac{7}{8}$ ins.

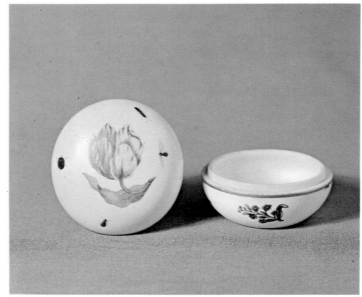

Hoff Antiques Ltd.

From about 1740 the early fashion for highly stylised flower painting
(*indianische Blumen*) after the original Chinese style began to give way to
a new, and very attractive, manner of painting. These paintings were
usually strictly accurate in the botanical sense, and can sometimes be
traced to original engravings used to illustrate the works of such botanists
as J. W. Weinmann, published between 1735–45.

 Such detailed specimens as seen on this box and cover are referred to as
Schnittblumen (cut flowers), or *ombrirte teutsche Blumen* (shadowed German
flowers, so called because certain decorators painted shadows behind the
blooms, a practice which often gave a pleasing three-dimensional effect).
There seems little doubt that several competent painters were engaged in
this form of decoration, but due to a single example being signed 'Joh:
Gottfr:Klinger, fec.' with the date 1742, the name Klinger is normally
used to describe it. This form of flower-painting was also imitated, in a
very naïve manner, on Chelsea porcelain of the triangle period
(1745–49).

Plate 6

Chess-piece in the form of an
elephant; hard-paste porcelain,
painted in enamel colours
Mark: crossed swords in
underglaze-blue
MEISSEN (Saxony); *c*.1745
Height 6¼ ins.

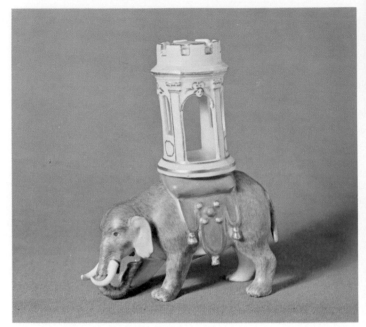

Hoff Antiques Ltd.

Porcelain chess-pieces featured very early in the history of Meissen and
were mentioned in 1725. These would have been modelled by former
ivory carvers or by Georg Fritzsche, who, although employed primarily
as a repairer (assembler), is also credited with modelling some of the
crude, but early, figures of dwarfs, pedlars, soldiers, etc. The Meissen
sculptor, Gottfried Müller, who is recorded as supplying wood-carvings
which were used as porcelain models, is also credited with making
models for chess-pieces.

 This very elaborate example of an elephant with a castle on his back, is
more likely to be the work of either Kaendler or his assistant, J. F.
Eberlein, who was employed from 1735 onwards.

Plate 7

Figure of a swan; hard–paste
porcelain, painted in enamel
colours
Mark: crossed swords in
underglaze-blue
MEISSEN (Saxony); 1747
Height 5 ins.

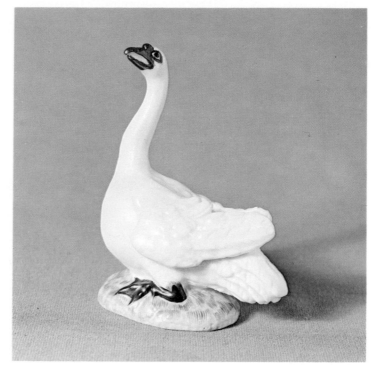

Hoff Antiques Ltd.

The swan is best known in Meissen porcelain because of the immense
Swan Service, which was made between 1737 and 1741 for Count Brühl
himself. The figure of a swan was used in low relief on many of the
tablewares, in association with such marine figures as Nereids, dolphins
and Tritons. (Many examples from this famous service can be seen in the
Dr. Ernst Schneider Collection now beatifully housed in the restored
Schloss Lustheim, a short distance north of Munich.)

The small figures of swans, as illustrated, were the work of Kaendler
and his assistant Peter Reinicke, who was appointed to the post in 1743.
Reinicke's modelling soon reached a standard that made it difficult to
distinguish from that of his master.

Plate 8

Sailor and sailor's wife; hard-paste
porcelain, painted in enamel
colours
Mark: (on sailor only) crossed
swords in underglaze-blue
MEISSEN (Saxony); c.1755
Height (of wife) 7½ ins.

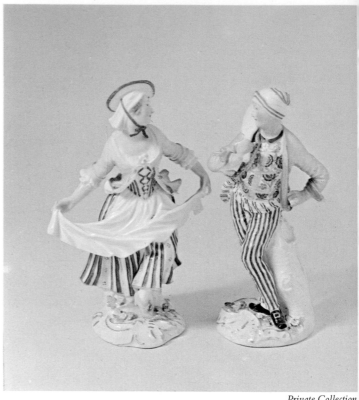

Private Collection

These two figures are typical of those modelled by Kaendler and his
assistants in about 1755 but the actual modeller is not recorded. It will be
noticed that the simple mound bases, sometimes sprinkled with full relief
flowers, had by this time given way to low rococo bases picked out in
gilding, a style probably inspired by the fashion for mounting porcelain
figures on bases of ormolu (gilt bronze). It is sometimes suggested that
this particular type of base was introduced to Meissen by F. E. Meyer,
who joined the factory as a modeller in 1748, having previously been
Court Sculptor at Weimar.

At about this same time the strong enamel colours, as seen on the
earlier Italian Comedy figures and groups of lovers, gave way to pastel
tones of green, lavender and yellow. The sailor holding a paddle (?)
appears to be a rather rare model and is illustrated in the 1966 publication,
Figuren II, of the Meissen *Porzellan-Manufaktur*. In order to support this
figure during the initial firing a substantial piece of clay, in the form of a
tree-stump, has been added for him to 'lean on'. It is noteworthy that
such supports were only rarely decorated during the 18th century. Full
decoration with enamel colours usually indicates a later date, most likely
in the 19th century.

Plate 9

Figure of a singing monkey; hard-paste porcelain, painted in enamel colours
Marks: '10' incised, and '49' painted
MEISSEN (Saxony); c.1750
Height 5 ins.

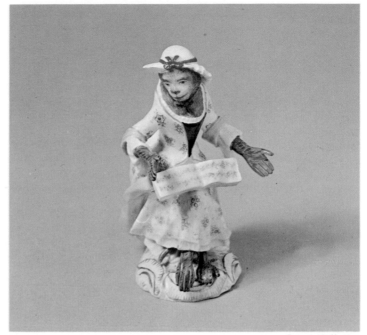

Private Collection

The Monkey Band (the *Affenkapelle*) are probably the best known of all Meissen figures. The original group of more than twenty features monkeys dressed in the costume of the period as musicians and choristers, together with the conductor of the orchestra. The modelling is attributed to Kaendler and dates to about 1750, a period indicated by the rococo-style bases. These same figures were being reproduced at the Chelsea factory in London by about 1755. They are typical of many of Kaendler's satirical models, the story being that they were made to ridicule the court orchestra of Count Brühl, an amusing, but highly improbable suggestion. In *Dresden China* W. B. Honey points out that monkeys in the guise of musicians had previously been traced back to some early designs of Watteau's master Gillot.

From about the middle of the 19th century many Continental factories made similar, but poorer quality figures. They were usually marked in a fashion deliberately designed to be confused with the crossed swords of Meissen, the most common of these marks including a device like a pair of scissors, two strokes crossed at right angles by a further two (as a frame for noughts and crosses), and two strokes crossed diagonally by a third. The well known crowned 'N' of the 18th-century Naples factory was also at times imitated.

Plate 10

Teapot; hard-paste porcelain,
decorated in enamel colours
Painted by Metzch of Bayreuth,
on Meissen teapot
MEISSEN (Saxony); *c.*1720
(decoration added at later date)
Height about 5 ins.

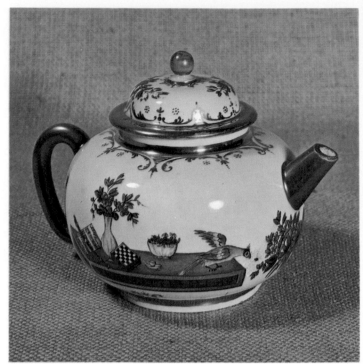

Hoff Antiques Ltd.

The term *Hausmalerei* (homework) is used to describe porcelain painted,
or otherwise decorated, away from the place where it was made. We are
concerned here with Meissen porcelain, but the same term applies even to
Chinese porcelain, decorated at the same period, in the many workshops
at such places as Bayreuth, Augsburg, Vienna and Breslau. The work of
these outside decorators varied greatly in quality. Sometimes it was
superior to that applied at the factory, but very often inferior and
inclined to be overdecorated to a confusing degree.

The workshop of Johann Friedrich Metzsch (*d.*1766), who is credited
with the enamel decoration on this teapot, was at Bayreuth during the
1740s. Metzsch seemingly had difficulty in obtaining sufficient quantities
of undecorated Meissen for his needs, and work attributed to him, or his
painters, is sometimes seen on Chinese porcelain. Known examples of
painting with the initials, or full signature of Metzsch, show a close
relationship to the harbour painting of Meissen.

Plate 11

Inkpot and pounce-pot; hard-paste
porcelain, painted in enamel colours
VIENNA (Austria); 1730
Diameter 3½ ins.

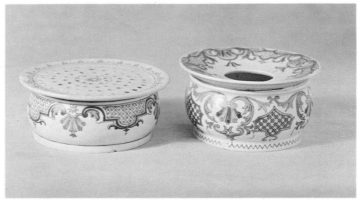

Hoff Antiques Ltd.

Claude Innocent Du Paquier was born at Trier, in Germany, in about
1680–85. For many years he had attempted to manufacture hard-paste
porcelain and, in desperation, he persuaded Cristoph Hunger to leave
Saxony, where he had claimed to have learnt the secrets of porcelain
manufacture from Böttger. Hunger's claims proved false and Du Paquier
did not manage to produce good porcelain in quantity until 1719, when
Samuel Stölzel, arcanist, kiln-master and a key-worker of the Meissen
factory, deserted from Meissen and went to Vienna on the promise of
very lucrative rewards. By April 1720, Stölzel had returned to Meissen,
together with Du Paquier's most talented employee, J. G. Herold, but by
this time Du Paquier had himself learnt how to produce a fine white
porcelain, and the departure of Stölzel and Herold, followed shortly by
Hunger, who went to Venice, merely caused a temporary halt to the
Viennese production.

Fine wares were again produced by Du Paquier within a very short
period, but due to lack of funds he was constantly in debt, until the
factory was eventually purchased by the Empress Maria Theresa in 1744.

This inkpot and pounce-pot date from the middle period of the Du
Paquier management (1725–35). The pounce-pot contained sand which
was sprinkled on writing to dry the ink. These comparatively humble
pieces of Vienna porcelain well illustrate the constantly recurring form of
decoration *Laub-und Bandelwerk* (foliate strapwork), shells and trellis so
typical of Viennese Baroque ornament. Through the influence of Italian
craftsmen the late-Baroque styles of all Viennese forms of art became less
ponderous than the early fashion, and more fitting for a city which by
the early 18th century was the accepted cultural centre of South-Eastern
Europe.

Plate 12

Cavalier and lady; white glazed
porcelain (hard-paste)
VIENNA (Austria); c.1735
Height 5¾ ins.

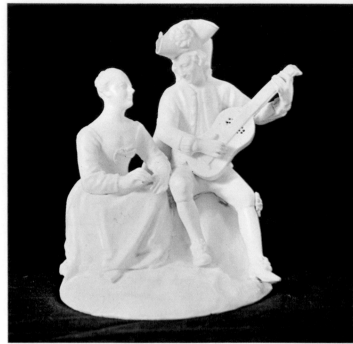

Hoff Antiques Ltd.

During the Du Paquier period there were very few good porcelain
figures produced. Those that were, usually took the form of full relief
decoration on such articles as clocks, vases, table centres, fountains,
inkwells, knobs to covers of tureens, or handles to mugs, etc. Being
'arrested' in this manner, such figures lacked the lively animation of the
contemporary creations made by Kaendler and his assistants at Meissen.
It has been suggested, but not generally accepted, that Du Paquier
occasionally employed confectioner's assistants, who made lavish
decorations in wax or sugar, and who were capable of adapting their
skills to the material of porcelain, rather than trained sculptors.

The more conventional figures made during the Du Paquier period are
very rare. The example illustrated has been left undecorated but similar
pieces can be attributed to the factory by their distinctive enamelling.
Being unmarked, pieces of this type are very difficult to attribute with
certainty. They are usually poorly modelled and suggest Du Paquier was
having difficulty in firing such wares with success.

Certain of Du Paquier's later figures appear to have been moulded
directly from earlier Meissen pieces, or modelled very closely from the
Saxon originals, but from the time that the Empress Maria Theresa
purchased the factory skilled modellers were engaged to create a whole
series of attractive figures. The earliest of this group remained unmarked
and it was 1749 before the two-bar shield of Austria became almost
consistently used, either incised, or in high-temperature blue.

Plate 13

Basket; hard-paste porcelain,
painted in enamel colours
Mark: an impressed shield
VIENNA (Austria); 1744–49
Width 7¼ ins.

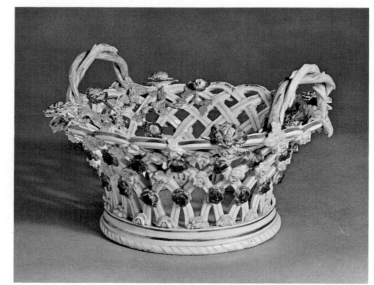

Clandon Park, National Trust (Gubbay Collection)

From 1744, when the Vienna porcelain factory was taken over by the
State, it was well organised, and its products were very high quality
although they rarely showed any originality. The designers and painters
there were influenced to a great extent by the current fashions of the
Meissen factory, especially as far as table-wares were concerned. Pierced
patterns, accompanied by relief flowers and leaves, as illustrated, were
particularly popular.

From 1760, when the factory painting was under the direction of
Philip Ernst Schindler, assisted by other decorators also recruited from
Meissen, wares decorated in high relief gave way to simpler forms, which
offered the painters wider scope for their peasant, hunting and Watteau-
like scenes, framed in gold rococo. From the time of the Seven Years
War, however, Vienna, in common with most other European porcelain
factories, turned towards Sèvres as the fashion leader in the world of
porcelain, and by 1770 both the forms and popular ground colours
introduced by the French factory, were being reproduced at Vienna.

By the 1780s the factory was going through a difficult period, due to
lack of competent management. It was at this time that the Emperor
Joseph II insisted the factory should revert to private ownership, but
despite being offered at a bargain price, there were no buyers, so in 1784
the factory was given over to the very efficient businessman Konrad
Sörgl von Sorgenthal, who was given an entirely free hand in the
running of the factory plus a salary and a percentage of the profits.
Sorgenthal's appointment marked a new and prosperous era in the life of
the factory, which continued until his death in 1805, after which the
concern again declined.

Plate 14

Cup and saucer; hard–paste
porcelain, painted in enamel colours
and gilt
Mark: shield of Austria in blue and
'5' incised
VIENNA (Austria); early–19th
century
Diameter (of saucer) 5¼ ins.

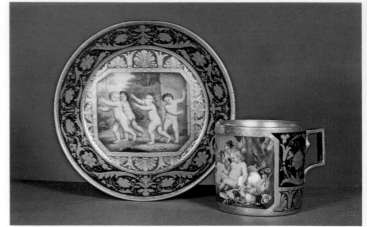

Victoria and Albert Museum

From 1783 many Vienna wares were dated. The date-marking consisted
of impressed numerals. Up until 1799 the last two numbers of the year
were used, after which it was the last three, hence '807' indicated 1807 as
the year of manufacture. Unfortunately this decree was not strictly
carried out, in addition many wares were decorated several years after the
firing and glazing of the porcelain.

Following the death of Schindler, Anton Grassi, who was initially
engaged as a modeller, took over as Art Director and also supervised the
decoration of table-wares. It was Grassi who introduced the early–19th-
century Vienna styles that are still poorly imitated on the Continent to
this day. From this time much of their decoration catered for the current
neo-classical taste, and was often inspired by the murals discovered
during the excavations at Pompeii. Also, many of the works of famous
old masters and later painters, such as Angelica Kauffmann, were
beautifully reproduced by the painters.

This cup and saucer well illustrate the fine quality to be seen on the
genuine Vienna wares of the period, which were plainly very superior to
the later imitations where the gilding has often been applied with the aid
of a rubber-stamp. Following the closing of the factory in 1864 many
undecorated wares were sold to outside decorators, who then added
earlier styles of decoration. Many of the early Vienna moulds for both
useful wares and figures were also used at the Schlaggenwald factory in
Bohemia for producing fakes.

Plate 15

Dish; hard–paste porcelain,
decorated in enamel colours
Mark: a crowned wheel
HÖCHST (Germany); *c.*1760
Width 9¾ ins.

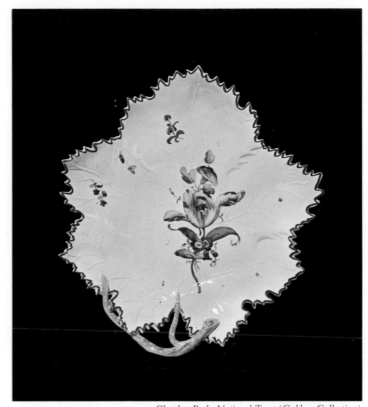

Clandon Park, National Trust (Gubbay Collection)

Although Adam Friedrich von Löwenfinck, who had formerly been
employed at Meissen, was working at Höchst from 1745, he seems only
to have made a refined type of tin-glazed earthenware. In the following
year Löwenfinck went into partnership with J. C. Göltz and J. F. Clarus
to establish a new factory, using clays from Weissenau. They managed to
obtain the services of many well known painters, moulders and various
workmen from other concerns, including members of the Hess family,
formerly working at Fulda. Following various disputes A. F. von
Löwenfinck left Höchst in 1748 for the Strasburg factory. During these
years there seems little doubt that the factory was concerned solely with
the production of faience.

Hard-paste porcelain appears to have first been manufactured at
Höchst in about 1750, when Johann Benckgraff and the well-known
arcanist J. J. Ringler, both of whom had previously worked in Vienna,
were employed. The leaf-dish illustrated shows features typical of early
Höchst porcelain table-wares in its rather coarse opaque body and
pleasing milky-toned glaze. The boldly painted flowers are certainly
more appropriate to the faience which was also produced at Höchst until
about the time of the death of Göltz in 1757.

Plate 16

Plate; hard-paste porcelain, painted
in enamel colours and gilt
Mark: six-spoked wheel in
underglaze-blue
HÖCHST (Germany); *c.*1765
Diameter 9¼ ins.

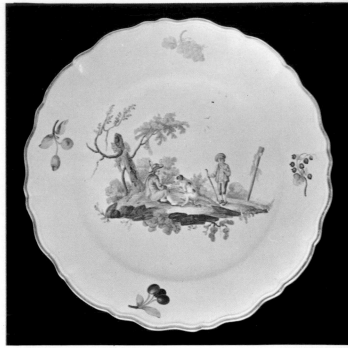

Hoff Antiques Ltd.

From about 1765 many good quality table-wares were produced at
Höchst. By this time the factory had been taken over by a group of
shareholders, who engaged Johann Kausschinger as Managing Director.
Although Kausschinger proved to be a very honest and competent man,
under whose direction the factory at first flourished, it went bankrupt in
1777. The factory was saved from closure by being given a large subsidy
by the Elector, but in 1778 it was taken over by the State.

It was during Kausschinger's period that the earlier landscapes,
chinoiseries and Meissen-like flowers, nearly all painted within gilt or
enamelled rococo scroll frames, gave way to new styles of unframed
paintings showing groups of peasants, after Teniers the Flemish artist.
One of the most competent painters at Höchst was Louis-Victor
Gerverot, who was employed at the factory during the 1770s, but he is
also known to have worked at many other concerns.

The mark used at Höchst on both faience and porcelain consists of a
six-spoked wheel. This device was taken from the arms of the Elector of
Mayence, who granted the factory a fifty year's privilege. This mark was
originally applied in enamel colours or gold and later in underglaze-blue.
The Electoral Hat, sometimes seen on top of the wheel mark, was not
used until about 1760, and appears to have been used generally until 1774,
after which either form of mark is acceptable.

Plate 17

Figure of a girl with dog; hard-paste porcelain, painted in enamel colours
Mark: six-spoked wheel in underglaze-blue
HÖCHST (Germany); *c*.1770
Height 6¼ ins.

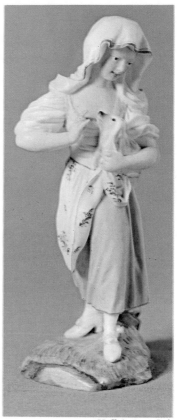

Hoff Antiques Ltd.

Among the earliest porcelain figures produced at Höchst were those attributed to the modeller Simon Feilner, who arrived at the factory in about 1751, remaining until 1753, when he went to Fürstenberg. His version of peasants and Italian Comedy figures were very much in the bold style of the Meissen modeller Kaendler.

This very attractive figure of a girl with a dog is the work of Johann Peter Melchior, who was engaged at Höchst in 1767 to replace Laurentius Russinger, the chief modeller from 1762–67. Melchior's style of modelling was something entirely new to this factory and clearly shows the influence of the French painter François Boucher. His best and most easily identified models are those of the early 1770s, when the painting of the flesh, clothing and grassy bases were all in paler tones of enamel, and much more desirable than the harsher colours used on his models after his departure for the Frankenthal factory in 1779. From this time the factory went into decline, and eventually closed in 1796.

Plate 18

Boy and girl playing instruments;
hard-paste porcelain, painted in
enamel colours and gilt
Mark: 'F' in underglaze-blue
FÜRSTENBERG (Germany);
c.1760
Height 4½ ins.

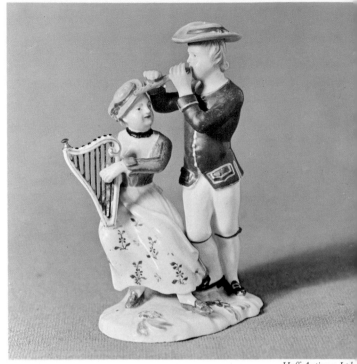

Hoff Antiques Ltd.

Experiments concerned with the making of porcelain were started at
Fürstenberg, Brunswick, at the instigation of Duke Karl of Wolfenbüttel
as early as 1747, but it was 1753 before success was finally achieved with
the assistance of Johann Benckgraff, Johann Zeschinger his son-in-law,
and Simon Feilner. Feilner remained at the factory as a modeller until
1768, during which time he produced many models of figures. These
include fifteen Italian Comedy characters, the earliest of which lack the
adopted factory mark of an underglaze-blue, cursive 'F', resulting in a
certain amount of confusion with similar models made elsewhere at a
later date.

The base of this boy and girl playing instruments is typical of many
early models attributed to Feilner, and appears to pre-date the later
editions of about 1775, when the fashionable rococo-scroll bases were
preferred. These figures often bear the incised initials of the repairer,
Casper Bocker.

Later Fürstenberg modellers also worthy of mention are J. C.
Rombrich, A. C. Luplau, Desoches and C. G. Schubert. The models
often bear incised numbers which can at times be identified with the
modellers mentioned in the list published by C. Scherer (*Das
Fürstenberger Porzellan*, Berlin, 1909). Research by Dr. Ducret has more
recently revealed the names of further Fürstenberg workmen, who were
most probably only concerned with the earlier production of faience.

Plate 19

Teapot; hard-paste porcelain,
painted in enamel colours and gilt
Mark: 'F' in blue and 'g' incised
FÜRSTENBERG (Germany);
*c.*1790
Height 4⅜ ins.

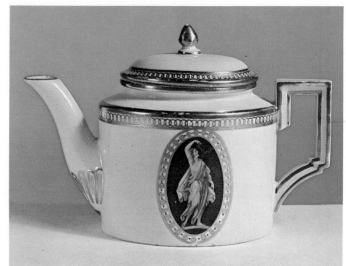

Victoria and Albert Museum

From about 1770 the extreme rococo styles, which had dominated the
Fürstenberg table-wares during the 1760s, gave way to early forms of the
neo-classical styles, probably as the result of influence from the
contemporary fashions of the Berlin factory.

This simple teapot is a typical example of the Fürstenberg designers'
and decorators' late-18th-century approach to neo-classicism, using
simple enamelled designs, inspired by the paintings, still to be seen today,
among the ruins of the excavated city of Pompeii.

From the last decade of the 18th century Fürstenberg also produced
many plaques of biscuit porcelain, made in imitation of the blue-and-
white jasper-ware cameos of Josiah Wedgwood. In addition some very
well modelled small portrait busts were created by C. G. Schubert. These
biscuit wares often bear the mark of an impressed running horse, used as a
factory-mark from about 1770. The Fürstenberg factory has continued to
this day as a limited liability company, and like several other present-day
German concerns, continues to produce wares from the old models.

Plate 20

Tray; hard–paste porcelain,
painted in enamel colours
Mark: a sceptre in blue enamel
BERLIN (Germany); 1770–75
Length 13⅜ ins.

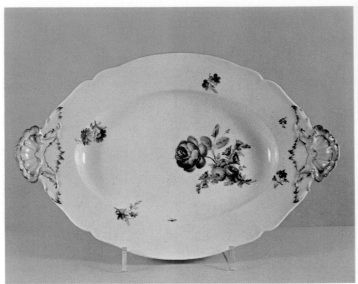

Victoria and Albert Museum

Today's collectors rarely have the opportunity of acquiring examples of the early Berlin hard-paste porcelain made between 1751 and 1757 at the factory started by W. K. Wegely, but wares made at the later Berlin factory, which continues to the present day, are often available, though usually of 19th-century date. Work was continued on a small scale at Berlin by E. H. Reichard, Wegely's chief modeller, from 1757 until 1761 when he joined J. E. Gotzkowski in the building of a new factory. This new partnership was unable to pay its way and was purchased by King Frederick the Great in 1763, when it became the Royal Factory, with a monopoly of porcelain sales throughout the entire country of Prussia.

The Royal Factory was exempted from normal tariffs and taxes, and certain sects and national concerns were compelled to spend fixed sums of money on the purchase of Berlin porcelain. Under such obvious advantages the factory naturally flourished and by the early 1770s were employing about five-hundred well-paid employees, who worked a twelve-hour day.

This tastefully decorated tray, with shell-like handles, was an early and popular design, which was produced over a long period. The finest Berlin flower painting is seen from about 1770, when a new style of painting in two harmonising colours was used, such as red and black, black and gold, or grey and pink, the latter probably being the most effective. The rose-pink, as seen on the tray illustrated, was a colour of which the factory was particularly proud.

The mark of the early Wegely concern consisted of a 'W', sometimes together with a series of inexplicable workmen's marks, in blue or impressed. Gotzkowski used a simple blue 'G'. From 1763 the usual mark was a sceptre in underglaze-blue and this mark is often seen together with an orb and the letters 'K.P.M.' printed in red or blue. These marks were added during the decorating stage and were used from 1832 onwards. From about 1832 to 1870 the mark sometimes consisted of a Prussian eagle, printed in red, brown or blue enamel.

Plate 21

Figure of Donna Martina; hard-
paste porcelain, decorated in
enamel colours
Mark: a shield impressed and
coloured
NYMPHENBURG (Bavaria);
*c.*1760
Height $7\frac{3}{8}$ ins.

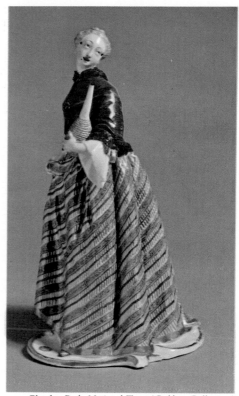

Clandon Park, National Trust (Gubbay Collection)

If the Nymphenburg porcelain factory had produced nothing but their
superb series of Italian Comedy figures, they would have justified their
fame as being one of the outstanding German concerns of the 18th
century. Experiments involved with the production of hard-paste
porcelain were first started at Neudeck, near Munich, in 1747. The
factory was supported by the Elector Maximilian III, Joseph of Bavaria,
but despite the expenditure of large sums of money, by various
incompetent 'arcanists', it was not until the engagement of the famous
J. J. Ringler in 1753, that a good quality porcelain was finally produced.
He remained at the factory until January, 1757.

Franz Anton Bustelli, who was employed in late 1754, became
Director of Modelling in 1756, at the age of 33. He is thought to have
died in 1763, but because Bustelli was a common name in Locarno,
where the modeller was born, various researchers in this field tend to
differ as to exact dates. Whilst Kaendler must be regarded as the master
porcelain modeller of the Baroque period, there is no doubt that during
the following rococo period Bustelli remained unsurpassed.

Many of Bustelli's earliest figures appear to have been inspired by the
Munich sculptor and wood-carver, Franz Ignaz Gunther, this is
particularly noticeable with his models of the Virgin Mary, St. John and
the Crucifixion. This influence is not so marked on his lovers, Chinese
figures, or Italian Comedy characters. An important discovery was
published in 1960 by Hellmuth Vriesen concerning Augsburg engravings
which depict over twenty various Italian Comedy figures and which
could be traced, by a signature, to Bustelli. These were probably used by
him when creating his models.

It was on his male figures that Bustelli used the movement of rococo so
ingeniously. He eliminated the customary tree-stump or pedestal, which
was used as a support during the biscuit firing, and in its place he
modelled a thin wave-like scroll, which in addition to strengthening the
thin, stockinged or trousered legs, helped to accentuate the animation of
his models. Bustelli was succeeded as *Modellmeister* by the sculptor
Dominicus Auliczek, who is best known for his realistic, and sometimes
sadistic, groups of fighting animals, which were usually left undecorated.

Plate 22

Tea-caddy and cover; hard-paste
porcelain, painted with enamel
colours and gilt
Mark: a hexagram in underglaze-
blue
NYMPHENBURG (Bavaria);
c.1765
Height 4¾ ins.

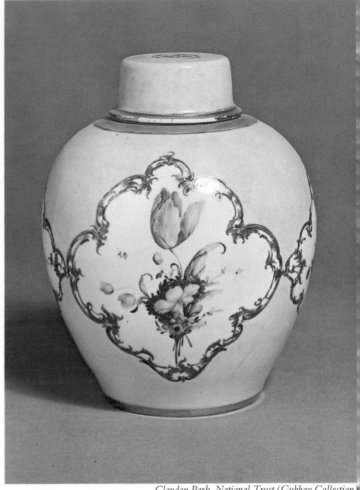

Clandon Park, National Trust (Gubbay Collection)

The table-wares made at Nymphenburg have always taken second place
to the figures just discussed, for, in common with table-wares from so
many other German factories of the second-half of the 18th century, they
showed very little originality in form or decoration. The flower painting
on this tea-caddy is very modest compared with the fine naturalistic
painting so often applied during the first ten or so years of the factory;
work associated with such decorators as G. C. Lindemann, J. Zächen-
berger and J. Reiss.

From 1754 the shield of Bavaria, the *Rautenschild*, was adopted as a
factory-mark, always impressed and often picked out in enamel colours
and gilt, as a feature on both figures and table-wares. An underglaze-blue
hexagram, using letters and numerals, was often added from 1763 to
1767.

Plate 23

Figure of a ballet dancer; hard-paste porcelain, decorated in enamel colours and gilt
Mark: lion rampant in underglaze-blue and monogram 'IAH'
FRANKENTHAL (Germany);
1756–59
Height 8¼ ins.

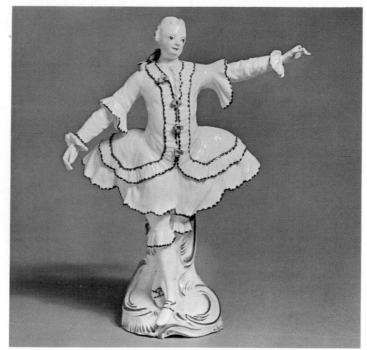

Clandon Park, National Trust (Gubbay Collection)

The fact that the authorities of the Royal Porcelain Manufactory at Vincennes were unable to come to an agreement with Paul Hannong of Strasburg concerning his early production of a hard-paste porcelain had two direct results. Vincennes and the later factory at Sèvres continued to produce a beautiful soft-paste porcelain, and Paul Hannong started production of hard-paste porcelain at Frankenthal under the patronage of Carl Theodor, Elector of the Palatinate. The factory was established in 1755 in some old barracks, and within a very short period was flourishing to such an extent that Hannong was able to return to his faience factory at Strasburg, leaving two of his sons, Karl and Peter Anton, to direct operations at Frankenthal.

Among the many workers who moved to Frankenthal from Strasburg with Hannong in 1755 was his chief modeller, Johann Wilhelm Lanz, who remained until 1761. During those six years Lanz modelled many attractive figures, some original, others obviously inspired by Meissen, but nearly all showing what W. B. Honey described as a 'seemingly artless simplicity and doll-like stiffness'.

This figure of a dancer is ascribed to the modeller Johann Friedrich Lück, who deserted from the Meissen factory in 1757, remaining at Frankenthal until 1764. Lück's models show a similar statue-like quality to many of the Lanz figures, but generally have a more robust and healthy appearance. The monogram 'IAH' on this figure is the initials of Joseph Adam Hannong, who became director of the factory in 1757.

Plate 24

Pair of figures of girls; hard-paste porcelain, decorated in enamel colours and gilt
Marks: lion rampant in underglaze-blue and 'I.H' incised
FRANKENTHAL (Germany); 1756–59
Heights 7¾ and 8 ins.

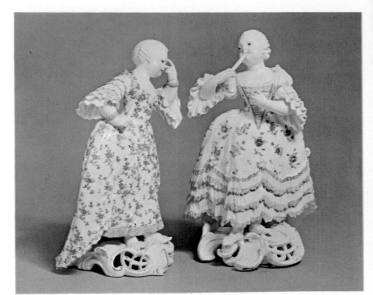

Clandon Park, National Trust (Gubbay Collection)

These two figures of beautifully dressed young ladies are typical of the modelling of Lück, who paid great attention to the details in the costume and the *coiffures* of his characters. Many of his figures were based on prints by such well known engravers as J. E. Nilson and Lancret. Similar figures were produced at Frankenthal during this same period by J. F. Lück's brother, Karl Gottlieb, who came to the factory from Meissen at the same time. He became *Modellmeister* in 1776, and remained at Frankenthal until 1775.

The initials 'I.H' are again those of Joseph Hannong (see page 39) who purchased the factory in 1758, but due to increasing debts was forced to sell the entire concern, including the secrets of the manufacture, to the Elector Carl Theodor in 1761, at a very low figure.

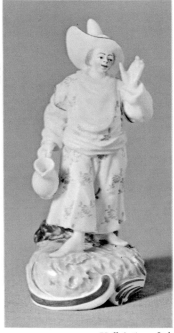

Hoff Antiques Ltd.

Plate 25

Figure of a man; hard-paste porcelain, painted in enamel colours
Mark: 'C.T' monogram under a crown in underglaze-blue
FRANKENTHAL (Germany); c.1765
Height 4⅞ ins.

Prior to his arrival in Frankenthal, K. G. Lück had for thirteen years been a pupil of J. J. Kaendler at the Meissen factory. According to well-known authorities on German porcelain modellers, the outstanding difference between the compositions of the two Lück brothers was in the bases they used. Johann Friedrich appears to have favoured the high pierced rococo type, whilst Karl Gottlieb preferred the more solid style of high rococo, of a type illustrated on this pleasing little chinoiserie figure of a man with a pitcher.

Further characteristics of K. G. Lück's figures which are present in this example are mentioned by W. B. Honey in his *European Ceramic Art* (see Bibliography), where he writes of 'the striped, spotted and flowered costumes of his period', 'distinctive cleanly modelled heads with pointed chins and noses' and 'green and gold-lined bases'.

Plate 26

Group; hard-paste porcelain, painted in enamel colours
Marks: 'C.T' monogram and crown in underglaze-blue
FRANKENTHAL (Germany); 1770
Height 9½ ins.

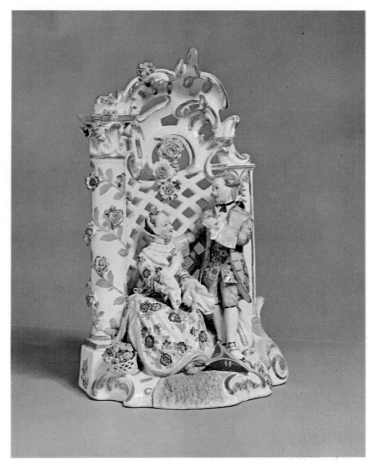

Clandon Park, National Trust (Gubbay Collection)

Although the name of Wilhelm Lanz is especially associated with figures of lovers seated in an arbour consisting of trellis surmounted with extremely 'wild' rococo scrollwork, similar backgrounds were often used by Johann Lück. The rather higher grassy rococo base also differs from the earlier flatter versions preferred by Lanz.

Soon after the Elector Carl Theodor purchased the Frankenthal factory from Joseph Hannong in 1761, he appointed Adam Bergdoll as the Director, who despite his inefficiency remained there until 1775, returning later for a further two years, from 1795–97, until his death. It was during this later period that the very fine modeller Konrad Linck was appointed. Linck, who was a court sculptor, remained at Frankenthal from 1762–66, but continued to supply models for the factory until about 1775. The fact that Linck was a talented sculptor is reflected in his compositions of mythological and allegorical subjects.

41

Plate 27

Jug; hard–paste porcelain,
decorated in enamel colours
Mark: 'C.T' under a crown, and
77, in underglaze-blue
FRANKENTHAL (Germany);
1777
Height 3¾ ins.

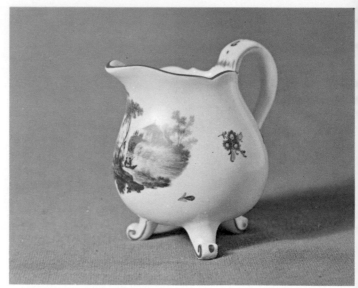

Hoff Antiques Ltd.

From 1770–88 the Carl Theodor mark of a 'CT' monogram under a
crown was often accompanied with the last two figures of the year of
manufacture, hence this example can be dated precisely to 1777. The
early Frankenthal vases and table-wares were often rather over decorated,
with extreme rococo moulding in the same fashion as Strasburg faience,
but during the 'Carl Theodor period' their wares were mostly influenced
by the current fashions of Sèvres. This very simple and unpretentious jug
is a style which had been popular for many years at the royal French
factory.

Following the 1794–95 wars the factory was confiscated by the
French, who leased it to Peter van Recum, who used a 'PVR'
monogram as a factory-mark. After one year the factory reverted to the
Elector, but during the following year it was once more taken over by
the French, and this time leased to Johann Nepomuk van Recum, who
used a 'J.V.R' monogram. The factory finally closed in 1799. The
modern Nymphenburg factory today makes a whole range of
reproductions from a large number of the original Frankenthal moulds,
in addition to those made at Nymphenburg.

Plate 28

Miniature group, men playing dice; hard-paste porcelain, decorated in enamel colours
Mark: interlaced 'C's in underglaze-blue
LUDWIGSBURG; 1760–65
Height $2\frac{7}{8}$ ins.

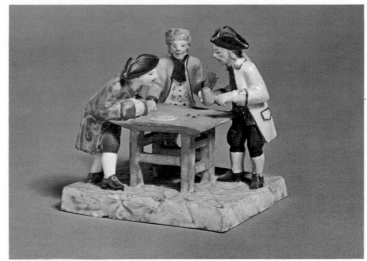

Clandon Park, National Trust (Gubbay Collection)

The porcelain factory at Ludwigsburg was established in 1758 and continued until 1824. This concern was patronised by the Duke Carl Eugen of Württemberg, who acquired the necessary knowledge concerning the manufacture by employing the nomadic arcanist J. J. Ringler (whose name is associated with the beginnings of at least eight other factories). It was this factory where, according to Dr. S. Ducret, author of *German Porcelain & Faience*, the workers were compelled to take part of their wages in faulty wares, which they then had to try and sell. Until the death of the Duke in 1793, the factory enjoyed a long period of prosperity, but after this time, when the subsidies ceased, the concern rapidly declined.

Ludwigsburg porcelain can often be identified by its rather drab 'broken-white' colour, probably the result of mixing poorer quality local clays with the finer materials they also obtained from Passau, in Bavaria.

J. J. Louis became Chief Modeller at the Ludwigsburg factory in 1762, remaining until his death in 1772. The factory records indicate that Louis, who was previously engaged at Tournai, was responsible for a large number of models of animals and humble characters, but he is probably best known for his delightful miniatures, which include busy groups of several figures at work or play. These groups are at times of a satirical nature, where, for instance, the hairdresser's assistant is searching the lady's hair for vermin with the aid of a telescope.

Plate 29

Pair of turkey sellers; hard-paste porcelain, decorated in enamel colours
Marks: interlaced 'C's and 'S' in underglaze-blue
LUDWIGSBURG (Germany); c.1775
Height 6½ ins.

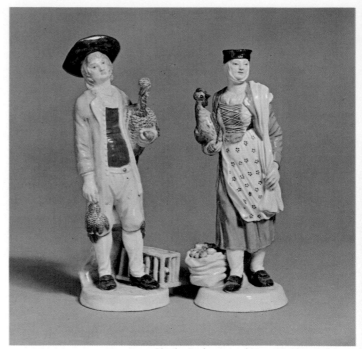

Clandon Park, National Trust (Gubbay Collection)

These two figures of turkey sellers are rather later in date than the dice players. Many well known modellers were employed at Ludwigsburg, including Johann Göz (*d*.1762); Carl Vogelmann, who by 1764 had moved to Kelsterbach; Haselmeyer; J. C. W. Bayer; Josef Weinmuller who is especially associated with groups of Chinese characters; Pierre Lejeune, and J. H. Schmidt, who was chief repairer at the factory from 1774, is attributed with many models produced in the late 1760s. The style of modelling of these two figures suggests the work of Bayer who, from about 1764, was Director of the modelling studio. The paler-toned colours, and the simple bases indicate that these are later editions than other similar known figures by this so-called 'Modeller of the Folk-types', which have the earlier rococo-scrolled bases of the pre-1765 period.

So many figures, by so many modellers, were produced at Ludwigsburg that certain identification of the craftsmen concerned is extremely difficult in most instances. The most common Ludwigsburg mark consists of two back-to-back 'C's, usually under a crown. A stag's horns, from the arms of Württemberg, were also occasionally used as a factory-mark.

Plate 30

Figure of a girl feeding chickens;
hard-paste porcelain, decorated in
enamel colours
Mark: a cross in underglaze-blue
FULDA (Germany); c.1770
Height 6⅛ ins.

Victoria and Albert Museum

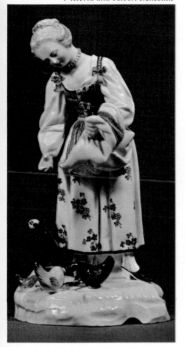

This most attractive figure of a girl feeding chickens has the simple
factory-mark used at the Fulda factory from 1765–80. This company was
established in 1764 by Heinrich VIII, Prince-Bishop of Fulda, aided by
Niklaus Paul, the arcanist formerly employed at Weesp, in Holland. The
factory continued in production until 1789. So little is known concerning
the modellers of Fulda, that pieces lacking a mark would be very difficult
to attribute.

Certain figures in Continental collections have been attributed by
German researchers, to Fulda's Chief Modeller, Wenzel Neu. The base of
this figure is more akin to those attributed to Georg Bartholomei, who
was at Fulda from 1771 until his death in 1788. His models rarely show
much originality, and would appear to have been inspired, in many
instances, by the models of the Frankenthal factory.

Victoria and Albert Museum

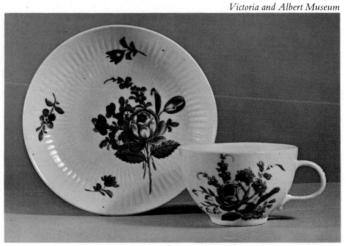

Plate 31

Cup and saucer; hard-paste
porcelain, decorated in crimson
enamel
Mark: crossed hayforks in
underglaze-blue
VOLKSTEDT (Germany);
1770–80
Diameter (of saucer) 5¾ ins.

This cup and saucer bears the 18th-century mark of the Volkstedt
factory, first established in about 1760 by G. H. Macheleid. The factory
was protected by the Prince Johann Friedrich of Schwarzburg-
Rudolstadt (d.1797) and the factory-mark of crossed hayforks taken from
the arms of Schwarzburg, is a mark which would appear to have been
deliberately adopted because of its similarity to the crossed swords of
Meissen.

Although the many later wares produced in the Thuringian factories
are of extremely poor quality, the 18th-century wares, such as this cup
and saucer, have a simple charm of their own. The moulded pattern on
the saucer can be seen on many Thuringian table-wares of this period.
The factory was purchased in about 1799 by Wilhelm Greiner and C. G.
Holzapfel. There was a further succession of owners during the 19th
century, and the factory is still in production.

Plate 32

Dish; hard-paste porcelain, painted
in underglaze-blue
Mark: 'W' in blue
WALLENDORF (Germany);
late-18th century
Width 8½ ins.

J. W. Hamman, J. G. Dümmler
and Gotthelf and Gottfried
Greiner, were all concerned with
the establishment of a hard-paste
porcelain factory in Wallendorf,
near Koburg-Saarfeld in 1763.
The factory remained in the hands
of the Hamman family until
1829, when it was taken over
by F. C. Hutschenreuter. It is
still in production today.

 According to 18th-century
records the main output of the
Wallendorf factory appears to
have been table-wares, rather than
figures. This very modest dish is

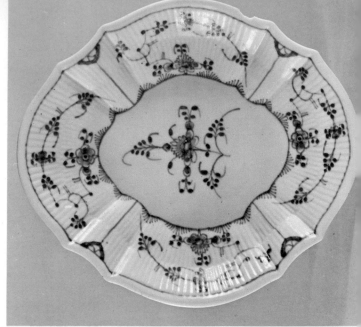

Victoria and Albert Museum

marked with the underglaze-blue 'W' often drawn to look somewhat
like crossed swords. The decoration, hand-painted in underglaze-blue,
represents the so-called *Zweibelmuster* (onion pattern), often used on
contemporary wares from Germany and Scandinavia. This pattern which
was undoubtedly derived from the Chinese painting of stylised peaches,
etc. was used at Meissen from as early as 1739.

Plate 33

Candlestick; hard-paste porcelain,
painted in enamel colours and gilt
Marks: shield and 'Dresden' in
blue enamel
POTSCHAPPEL (nr. Dresden)
Germany; late-19th century
Height 8 ins.

Victoria and Albert Museum

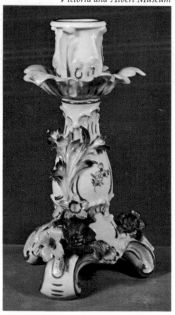

The factory of Carl Thieme was established at Potschappel, Dresden, in
1875, hence any wares made by this firm are of very little consequence to
the serious ceramic collectors. The factory is known to have used a
variety of marks, some including the initials 'CT', or in the form of a
monogram, other marks of this factory, which include the word
'Dresden', must in no way be associated with the earlier Meissen concern.
A more confusing mark is a simple diagonal cross (X), with 'T', this
mark is sometimes seen to have been tampered with, to make it look a
little more like the crossed swords. Like so many of the 19th-century
German wares, the Potschappel pieces are usually of a high quality,

which might well deceive the new collector. In this example it is the use of pale green and pink enamels on the candle-holder, drip-pan and base, which indicate its late-19th-century date.

Plate 34

Miniature group; hard-paste porcelain, decorated in enamel colours and gilt
Mark: Made in Germany
THURINGIA (Germany); *c.*1910
Height 3 ins.

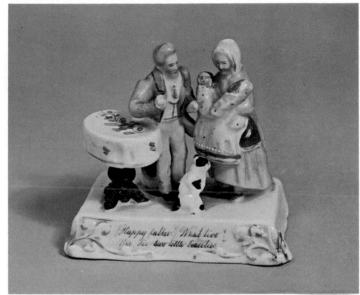

Constance and Anthony Chiswell Antiques

The factory at Pössneck was started in about 1790, but it was not until the second half of the 19th century that they began to produce large quantities of poorly modelled groups, often depicting scenes which at that time would have been considered rather risqué. Groups of this type are referred to as Victorian Fairings and at present are commanding prices which cannot fail to encourage the manufacture of reproductions.

The mark usually associated with Pössneck is impressed, and consists of a dagger being held aloft by a mailed arm, within a concave-sided shield. This mark must not be confused with that of the Bohemian factory of Elbogen, who used a mark of a similar style (see *Handbook of Pottery & Porcelain Marks*).

The fact that the inscription of 'Happy Father, What two? Yes, Sir, two little beauties!', is written in English, must not be allowed to confuse the collector, these groups were produced in Germany especially for the English market. This example is rather late and marked 'Made in Germany', indicating a date of about 1910.

Plate 35

Cup and saucer; hybrid hard-paste
porcelain, decorated in enamel
colours and gilt
DOCCIA (Italian); third quarter
of the 18th century
Diameter (of saucer) $5\frac{3}{8}$ ins.

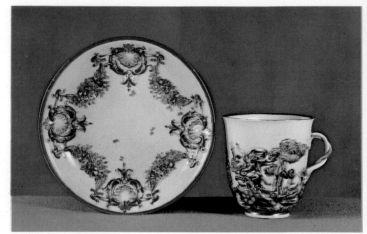

Victoria and Albert Museum

Old Italian porcelain is not often available to the ceramic collector in this
country, and the chances of finding a piece of the famous soft-paste
porcelain of Capodimonte are practically nil. Many new collectors still
have the impression that wares decorated in the manner of this cup and
saucer were made at the Capodimonte factory, and that the mark used
was a crowned 'N' in blue. This is not so, both Capodimonte (1743–59)
and the continuing Buen Retiro factory, near Madrid in Spain
(1760–1812), only used the mark of a fleur-de-lys, impressed, in blue or
gilt.

The crowned 'N' mark rightly belonged to the Royal Naples factory,
where soft-paste porcelain was produced from 1771–1806. The crowned
'N' mark was fraudulently used during the 19th century on hard-paste
German porcelain, decorated in the characteristic way illustrated.

The factory credited with the introduction of this much copied style
was founded at Doccia, near Florence, in 1735, and is still associated with
the original Ginori family under the name of Richard-Ginori. Arthur
Lane in his admirable book on *Italian Porcelain* (see Bibliography) writes
of the evidence he found in the factory archives for attributing these
hybrid hard-paste porcelain wares 'with figure subjects in low relief' and
'Saucers with garlands in relief, painted', to the factory of Doccia.

Plate 36

Cup and saucer; hard-paste
porcelain, painted in enamel
colours and gilt
Mark: an anchor in red enamel
VENICE (Italy), Cozzi's factory;
*c.*1770
Diameter (of saucer) 4⅝ ins.

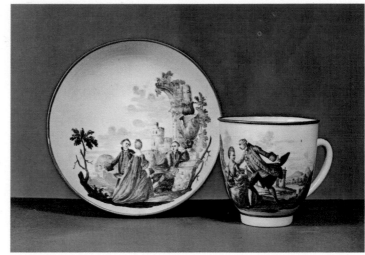

Victoria and Albert Museum

The first porcelain factory to be established within the territory of Venice
was that of Francesco Vezzi. The undertaking survived from about 1720
to 1727, during which time some very fine hard-paste porcelain was
produced from raw materials imported from Saxony. It is only on rare
occasions that Vezzi porcelain becomes available to modern-day
collectors.

Porcelain made at the later Venetian factory, which was started in 1764
by Geminiano Cozzi, are more frequently encountered. This factory
obviously produced a mass of material and continued in operation until
1812, the later output including cream-coloured earthenware of the
English type. The enamel painting of the Cozzi factory invariably
included the popular Italian iron-red, violet and emerald green, which
appear rather heavy and harsh on the greyish hard-paste porcelain when
compared with the contemporary German wares. The adopted factory-
mark of an anchor in iron-red was fairly consistently applied to their
table-wares, but rarely seen on their poor quality figures, many of which
were influenced by early Roman sculpture.

49

Plate 37

Sugar-bowl and cover; decorated
in enamel colours and gilt
Mark: 'FRF' monogram under a
crown in blue enamel
NAPLES (Italy); *c.*1775
Height $4\frac{5}{8}$ ins.

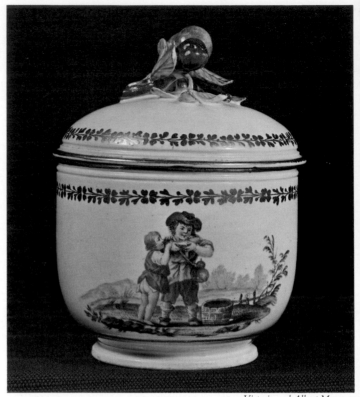

Victoria and Albert Museum

The Royal Porcelain Factory of Naples was established by King
Ferdinand IV in 1771, first at Portici, near the Royal Villa, moving in
1773 to a new building within the city of Naples. The porcelain, a glassy
soft-paste, of a quality which, when at its best, equalled that of the earlier
Capodimonte factory of Charles of Bourbon, father of Ferdinand. From
1779, when Dominico Venuti was appointed Director, both the forms
and decoration of their wares, tended to be influenced solely by the new
interest in neo-classical styles, popularised by the excavations which had
been carried out since 1738 at Herculaneum and Pompeii. The first official
publications were published from 1757 under the title *Le pitture antiche
d'Ercolano* and the engraved plates illustrating these volumes were often
used as a source of decoration on Naples services which were marked on
the reverse with a reference to the appropriate volume and plate number.

The earliest mark used at this factory was an 'FRF' monogram under a
crown (*Fabbrica Reale Ferdinandea*) painted in blue, red or black enamel.
The crowned 'N', previously discussed, was not introduced until towards
the end of the 18th century.

Plate 38

Flower vase; hard-paste porcelain, decorated in enamel colours and gilt
Mark: 'Nove' and star in gilt
LE NOVE (Italy); *c*.1800
Height 6½ ins.

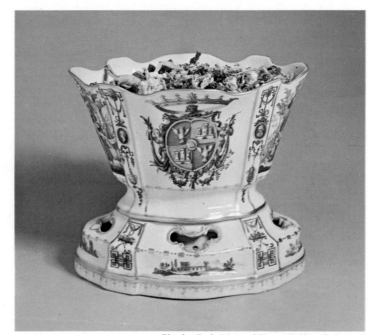

Clandon Park, National Trust (Gubbay Collection)

There is a great similarity between the porcelain made at Venice by Cozzi and that produced from 1762 by Pasquale Antonibon, who also had a factory for the manufacture of tin-glaze earthenware (maiolica), at Le Nove, near Bassano. As a result of Antonibon's ill-health and disloyal workmen, his porcelain factory appears to have been dormant for a long period of time until 1781, when it was leased to Francesco Parolin. In 1802 the factory again changed hands, this time to Giovanni Baroni who continued to run the concern until it was closed in 1825.

This very practical flower vase is made in two sections, the cone-like flower-holder is pierced at the bottom and sits into the tray-like water holder, thus making it possible to change the water without disturbing the flower arrangement. This shape was first referred to in the records of the French factory of Vincennes in 1754, where it was described as a *vase hollandois*. The most common factory-mark used on Le Nove porcelain was first adopted by Antonibon. It takes the form of a six-pointed asterisk, made up of crossed strokes, in either red enamel or gold and sometimes accompanied by the word 'Nove'.

Plate 39

Teapot and cover; hard–paste
porcelain, decorated in enamel
colours and gilt
Mark: 'M.O.L.' in blue
OUDE LOOSDRECHT
(Holland); *c.*1775
Height 4⅝ ins.

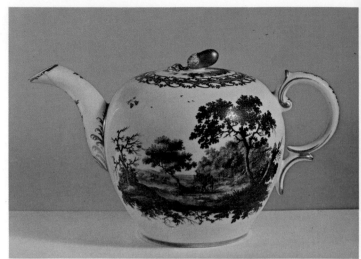

Victoria and Albert Museum

The hard–paste porcelain of Holland is rarely encountered outside of
museums. This is possibly because most of it is so dull and unoriginal that
few collectors would be interested.

Porcelain was first produced in 1762 at Weesp and as it was an entirely
commercial concern like the English factories, it did not have the
advantages of subsidies and privileges which so many of the German and
French factories enjoyed. Following the death of the owner, Count van
Gronsveldt-Diepenbroik in 1771, the factory was purchased by Johannes
de Mol, who transferred it to Oude Loosdrecht, near Hilversum, where
this attractively decorated teapot was produced. After Mol's death in
1784, the factory was once more transferred, this time to Ouder Amstel.

Most of the wares made at Oude Loosdrecht are superior to those of
Weesp. Their porcelain is whiter and the shapes are better proportioned.
The painting in this instance is probably a little too heavy and large, and
certainly appears to have been influenced by the style of landscape
painting associated with some of the finer Dutch artists. The 'M.O.L'
mark could be either for 'MOL: OUDE LOOSDRECHT', or just the
owner's name, the frequent use of a colon between the 'M' and 'O'
suggests the former.

Plate 40

Plate; hard-paste porcelain,
painted in enamel colours and gilt
Mark: three wavy lines in
underglaze-blue
COPENHAGEN (Denmark);
1780–90
Diameter 9¼ ins.

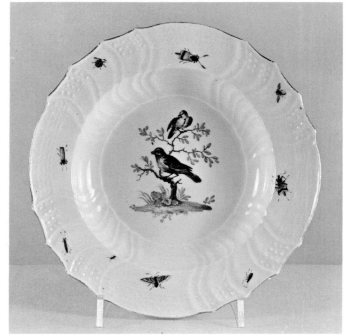

Victoria and Albert Museum

During the first half of the 18th century various attempts were made by
charlatan arcanists to produce porcelain in Denmark. It was not until
1759 that the French potter, Louis Fournier, who had worked at both
Vincennes and Chantilly, started to produce a soft-paste porcelain in
Copenhagen. Due to high costs King Fredrik V called a halt to the
production in 1765. True porcelain was eventually produced in
Copenhagen by F. H. Müller in 1775 and this concern became The
Royal Danish Porcelain Factory in 1779, when it was taken over by the
King. The factory still flourishes today as the Royal Copenhagen
Porcelain Co. Ltd., with showrooms in London.

Müller's early porcelain was of a bluish-grey tone, somewhat similar to
Chinese export porcelain of the same period. His decoration consisted
primarily of under-glaze-blue, purple, or iron-red painting of designs
which can often be traced to Meissen, or other German factories. From
1779 Müller succeeded in engaging several skilled painters and other
workmen from various German porcelain factories. The osier pattern on
this plate was certainly inspired by Meissen, where a variety of similar
basket-work borders were used, whilst the bird-painting was most
probably suggested by a popular Berlin pattern, which can be seen on a
large service in Chatsworth, the stately home in Derbyshire.

Plate 41

Pair of figures; hard-paste
porcelain, decorated in enamel
colours and gilt
Marks: 'G' in underglaze-blue,
and 'Gardner' impressed in
Russian characters
MOSCOW (Russia); Gardner's
factory; *c*.1830
Height 4½ ins.

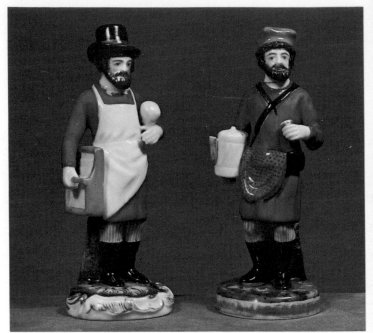

Victoria and Albert Museum

Following the production of a hard-paste porcelain at Meissen in 1710,
the Court of Russia, in common with the courts of many other
European countries, started a series of experiments concerned with the
manufacture of a similar material. From 1744 to 1748, Hunger, the
charlatan arcanist from Saxony, worked at a factory in St. Petersburg,
built at the request of the Empress Elizabeth, but his claim that he
possessed the necessary knowledge again proved false and he was
dismissed, after having wasted a great deal of money. It was Dmitri
Vinogradov, Hunger's assistant, who continued the experiments and
succeeded in producing a hard-paste porcelain, which by the early 1750s,
was to equal that of Meissen, but wares produced at the Imperial State
factory are far less common today than those made at the several
privately owned concerns which were established later in the 18th
century.

These two figures represent a glazier, with his wooden frame
containing sheets of glass, and a merchant. Both were produced at the
Gardner factory, established in 1767 at Verbilki, near Moscow. Very little
is known of Francis Yakovlevich Gardner, who arrived in Russia in
1746. His material is of inferior quality to that used at the St. Petersburg
factory, but has more in common with the Chinese export wares.
Gardner's factory was patronised by Catherine II, for whom he produced
some very impressive table wares, decorated with enamel and gilt
representations of leading Imperial Orders of chivalry. Apart from these
outstanding services, Gardner produced a very large variety of figures, or

'dolls' as they were called, from about 1785 to 1840. The exact dating of these figures is difficult but the letter 'G', in underglaze-blue, is considered to be the earlier form of the Gardner mark. It was continued into the 19th century, but was more carelessly applied in the later years.

Plate 42

Teapot; hard-paste porcelain, painted in enamel colours and gilt Marks: the Russian eagle enclosing 'AII', and 'FABRIC GARDNER' on a band enclosing St. George and the dragon, printed in red MOSCOW (Russia); Gardner's factory; 1855–81 Height 3¾ ins.

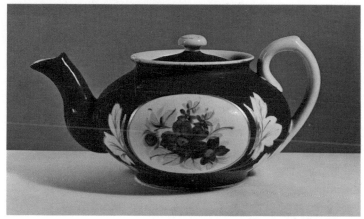

Victoria and Albert Museum

This teapot is of a type which appears to have been exported to many countries and the mark is a late version consisting of Gardner's name in Russian characters and the double-headed Russian eagle, together with 'AII' for Alexander II (1855–81). In 1892 the Gardner factory was sold to M. Kuznetsov, who was already the owner of several other porcelain factories in Russia. During the first half of the 19th century several other Russian porcelain factories were established, some of which are noteworthy.

The porcelain made at the Kievo-Mezhigorskaya Fabrika at Kiev was of a very high quality, often favouring decoration of full relief flowers and foliage. In 1811 A. G. Popov took over a factory which had been established five years earlier in Gorbunov, near Moscow. From 1818 until 1885 the factory started by N. S. Kudinov, at Lystsovo, near Moscow, produced garishly decorated wares (of the same type as the Gardner teapot illustrated) which were also exported to Persia and other Eastern countries. Russian porcelain, of the poorer quality export type, can often be seen today by visitors to the former palaces of the 19th century rulers of the various minor States, which are now embodied in such countries in Eastern Europe as Yugoslavia.

Plate 43

Pair of *cachepot;* soft-paste
porcelain
Mark: 'St.C./T' in underglaze-blue
SAINT-CLOUD (France); *c.*1740
Height 4¾ ins.

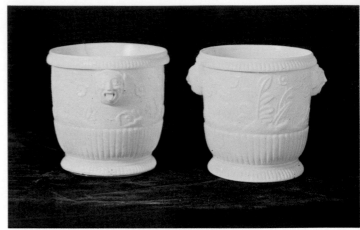

Hoff Antiques Ltd.

Although it is known that Edme Poterat of Rouen was granted a patent
in 1673 for the production of both faience and porcelain, he appears to
have concentrated on the former. The limited amount of soft-paste
porcelain which was produced at Rouen is very difficult to separate from
that of the more productive factory at Saint-Cloud.

Pierre Chicaneau, who died in 1678, is credited with producing a soft-
paste porcelain, which was later improved upon by his family, who from
the late-17th century until 1766, were concerned with the Saint-Cloud
factory. The creamy-coloured paste of Saint-Cloud is one of the most
distinctive types of soft-paste ever produced. Due to the nature of the
glassy material, it was obviously necessary to concentrate on thickly
potted wares, designed and decorated in a manner which made their bulk
less obvious.

Flowerpots of this form were produced in many sizes. They were
doubtless inspired by *blanc-de-Chine*—Chinese porcelain exported from
the Fukien province from the second half of the 17th century. These pots
with either the typical applied oriental flowering prunus, or moulded
with stylised plants as seen here, are also known in Staffordshire salt-
glazed stoneware.

Plate 44

Sugar-bowl and cover; soft-paste
porcelain, decorated in underglaze-
blue
Mark: a sun face in
underglaze-blue
SAINT-CLOUD (France); c.1735
Height 4¼ ins.

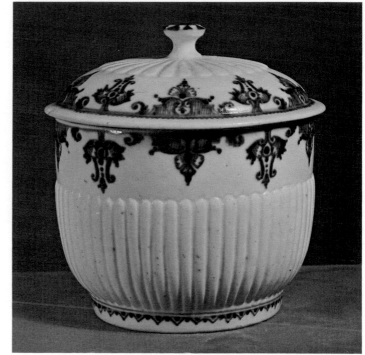

Victoria and Albert Museum

Small boxes, bowls and pots were produced at Saint-Cloud to serve a
variety of purposes both on the dining-table and for toilet use. The deep
reeding, as shown on this pot and cover, had the effect of lightening what
would otherwise be a rather cumbersome object and many other table-
wares were similarly treated. The underglaze-blue decoration, referred to
as lambrequin, is a style first seen on faience made at Rouen. Many Saint-
Cloud wares were decorated in this fashion until at least 1740.

This bowl is marked with the early 'sun face' in blue, the more
common mark seen on the wares of this early French factory is 'St.C'
above a 'T', in either underglaze-blue or incised into the clay under the
glaze. This mark must indicate a date after 1722, when Henri Trou II, a
son of the second marriage of Pierre Chicaneau's widow, was granted a
renewal of the original patent.

Plate 45

Tea-pot; soft-paste porcelain,
decorated in enamel colours on a
tin-glaze
Mark: a French hunting-horn
in red enamel
CHANTILLY (France); *c.*1730
Height 3⅛ ins.

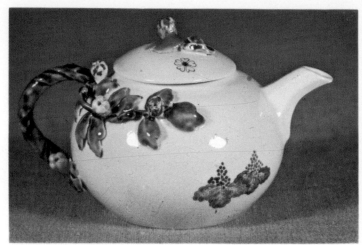

Victoria and Albert Museum

The second important porcelain factory to be established in France was
situated at Chantilly, north of Paris, where a good quality soft-paste was
produced from 1725 until about 1780. The founder of the factory was
Louis-Henri de Bourbon, Prince de Condé, with Ciquaire Cirou (*d.*1751)
as the director. The Prince possessed a large collection of Japanese
porcelain, decorated in the so-called Kakiemon manner, and these objects
were apparently used as patterns for the majority of the table-wares
which were made at the factory until about 1740 when the Prince died.
In addition, several of the Chantilly versions of the Kakiemon style were
imitations of those introduced at Meissen, which included the red dragon
and the panels of stylised flowers on an Imperial yellow ground.

In order to make the soft-paste porcelain look more like the original
Japanese hard-paste, the Chantilly glaze on these early wares was
opacified by the addition of tin oxide, a form of glaze usually reserved
for earthenwares. These early pieces were not consistently marked, but
the most common factory-mark used on the tin-glazed wares was the
well known French hunting-horn in a red enamel, a mark at times seen
on hard-paste porcelain reproductions made during the 19th century.

Plate 46

Plate; soft-paste porcelain,
decorated in underglaze-blue
Mark: hunting-horn and
'Chantilly' in underglaze-blue
CHANTILLY (France); *c.*1775
Diameter 9½ ins.

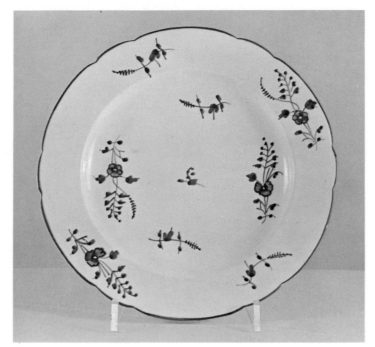

Victoria and Albert Museum

Following the death of Ciron, the wares at Chantilly became less
interesting. Although a tin glaze was occasionally applied on special
orders, that normally used was the more usual translucent lead glaze,
giving a slightly yellowish hue. A more carelessly drawn hunting-horn
was still used as their customary mark, but usually in underglaze-blue,
although coloured enamels, or gold, were sometimes used, often
accompanied by the incised names of workmen.

From about 1750 Chantilly shapes and styles of decoration, tended to
imitate those introduced at Vincennes or Meissen, although the
naturalistic flower painting of the German factory took on a fresh charm
when applied to the French soft-paste.

It was from 1760 that many of the Chantilly table-wares were painted
with the familiar underglaze-blue sprigs of flowers, etc., a style known as
the 'Chantilly sprigs'. This technique was imitated by other French and
English factories. From about 1792 until about 1800 the factory was run
by the Englishman Christopher Potter, who also owned a hard-paste
porcelain factory in Paris. For most of the 19th century, other smaller
Chantilly concerns continued to make rather poorer quality traditional
wares in a hard-paste. The hunting-horn was still used as a mark, often
accompanied by the names or initials of the owner of the concern.

Plate 47

Figure of a cockatoo; soft-paste
porcelain, painted in enamel
colours
Mark: 'DV' in manganese
MENNECY (France); c.1750
Height 5¼ ins.

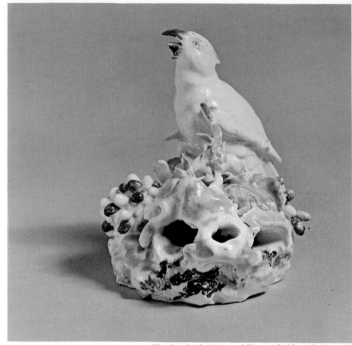

Clandon Park, National Trust (Gubbay Collection)

The soft-paste porcelain of Mennecy was not an ideal material for
making figures with any intricate detail, and the choice of shape was
inevitably influenced by a need for simplicity.

In addition to the outstanding groups of children (see page 61)
Mennecy also produced some small figures of Orientals, painted in the
Kakiemon range of enamel colours, and a limited number of white
glazed figures, which were modelled in a very sculptural manner. These
white figures are mostly attributed, on the grounds of marked pieces, to
Nicolas Gauron, who also worked at Vincennes and Tournai. This
charming figure of a cockatoo bears the 'DV' mark in manganese
(purple). The obvious soft-paste is typical of all the early French factories
discussed.

Plate 48

Two toilet boxes; soft-paste
porcelain, decorated in enamel
colours
Mark: 'DV' incised
MENNECY (France); *c.*1760
Heights $2\frac{1}{2}$ and $3\frac{3}{4}$ ins.

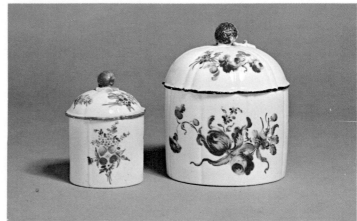

Clandon Park, National Trust (Gubbay Collection)

The third important French soft-paste porcelain factory was started in
1734 in Paris, under the protection of Louis-François de Neufville, duc de
Villeroy. The concern was transferred to Mennecy in 1748, where
production was continued until 1773, when a further move took place,
this time to Bourg-la-Reine, where it remained until 1806. The later
years were most probably concerned solely with the manufacture of
cream-coloured earthenware, of the Wedgwood type.

During the Paris and Mennecy periods, the usual factory-mark was an
incised 'DV' ('de Villeroy'), but following the move to Bourg-la-Reine
the owners, Jullien and Jacques, registered the new mark of an incised
'BR'. The early paste of Mennecy was a beautiful material, with a glaze
described by W. B. Honey in *French Porcelain* as 'wet' and brilliant.
Simple vertical-walled toilet boxes, of the type illustrated, were a form
which was used at most of the early French porcelain factories. There is
probably no better illustration of the manner in which enamel colours
tend to fuse into the glaze of soft-paste, than is found on wares of this
type.

From about 1760 some very fine, and rare, figures were produced. The
best of these depict groups of chubby children, probably inspired by the
painting of François Boucher. The newcomer to the ceramic field could
well confuse such compositions with the wares of the English Bow
factory.

Plate 49

Wine-cooler; soft-paste porcelain,
decorated in enamel colours and
gilt
Mark: crossed 'L's enclosing
letter 'q' (1769)
SEVRES (France); 1769
Height 9 ins.

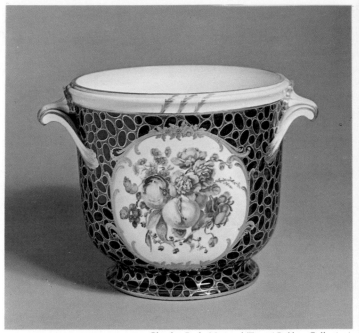

Clandon Park, National Trust (Gubbay Collection)

Knowledge concerning the early manufacture of soft-paste porcelain at
Vincennes is a little vague. It was in about 1739 that Gilles and Robert
Dubois, who had previously worked at the porcelain factory at
Chantilly, started their experiments in the old Royal château at
Vincennes at the request of Orry de Fulvy (*d.*1751). The Dubois were
shortly succeeded by a further Chantilly workman, Louis-François
Gravant, who was apparently more successful in producing a good soft-
paste porcelain, resulting in the formation of the Charles Adam
Company in 1745. This company was granted various royal privileges to
manufacture porcelain decorated in the styles of Meissen, they were
given larger premises, and workers were prevented from taking their
acquired knowledge to rival concerns, which in turn were forbidden to
employ Vincennes workers.

In 1753 a new company was formed and the royal cipher of the two
interlaced 'L's was officially adopted as a factory-mark. It was during this
same year that work was started on the building of a new factory at
Sèvres, between Paris and Versailles. The new premises were completed
and occupied in 1756.

This fine wine-cooler is one of a pair decorated with the early
underglaze-blue ground colour, first referred to in the factory records of
1753 as *bleu lapis*, later also known as *gros bleu*. These large areas of strong
colours were often broken down, in the fashion illustrated, with various
forms of gilding, described at the factory as *caillouté* or *vermiculé*.

Plate 50

Ewer and basin; soft-paste
porcelain, decorated in enamel
colours and gilt
Marks: crossed 'L's enclosing
letter 'r' (1770) and ','
SEVRES (France); 1770
Height (of ewer) 9 ins.

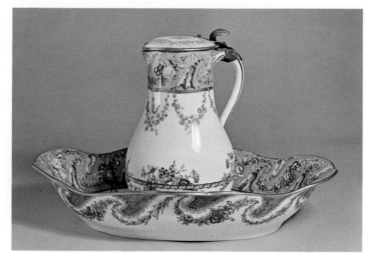

Clandon Park, National Trust (Gubbay Collection)

From 1753 the factory adopted a system of date-marking which consisted
of a letter within the crossed 'L' cipher mark, starting with 'A' for 1753,
'B' for 1754, etc. and continuing alphabetically into double-letters until
1793, when the factory was taken over by the First Republic. In order to
identify their work for checking purposes, the factory decorators were
also required to mark their painting, or gilding, with initials or a device.
The 'comma'-like mark on this ewer and basin indicates the work of
Thévenet, who was employed at the factory, as a flower painter from
1741 to 1777.

Knowledge concerning the dates and specialities of the painters often
helps one to recognise reproductions, or re-decorated wares. People
concerned with the manufacture of these later wares found it difficult to
resist marking these pieces with the earlier and more famous painter's
marks. Rosset, Micaud, Bulidon and Méreau are recognised as having
been the most accomplished of the flower painters, Le Doux, Aloncle and
Chappuis specialised in painting birds, whilst Morin and Dodin gained
reputations for being the most skilful painters of human figures.

Plate 51

Tray; soft-paste porcelain,
enamelled in colours and gilt
Marks: crossed 'L's enclosing
letter 'r' (1770) and 'm'
SEVRES (France); 1770
Width 9¾ ins.

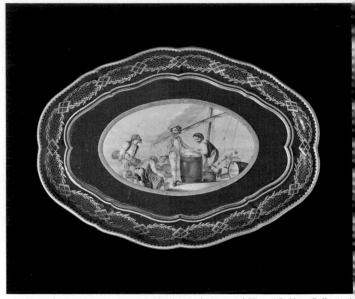

Clandon Park, National Trust (Gubbay Collection)

This tray is decorated in the later blue enamel referred to, in the sales
records of 1763, as *bleu nouveau*. Being an enamel it lacks the pleasing
variation in density of the earlier *bleu lapis* and is, at times, almost garish.
The more common name used today for this ground colour is *bleu du roi*
(royal blue).

From the time that King Louis XV became financially involved in the
factory, various court artists and technicians were called upon to apply
their various skills to the new production. The man credited with the
introduction of so many of the fine enamel colours used was Jean Hellot,
who was both a competent chemist and a member of the Académie des
Sciences.

The painter's letter 'm' on this tray is almost certainly the mark of
Jean-Louis Morin, who worked at both Vincennes and Sèvres from 1754
until 1787. Morin was at first engaged in painting the popular cupids but
later specialised in busy port scenes, which included detailed views of
shipping, figures of wharf-side workers, and military subjects.

Plate 52

Ewer and basin; soft-paste
porcelain, enamelled in colours
and gilt
Marks: crossed 'L's with 'P' and
'Y'
SEVRES (France); *c.*1775
Height (of ewer) 8 ins.

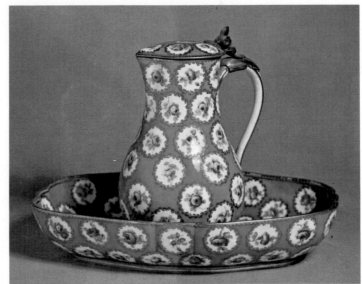

Clandon Park, National Trust (Gubbay Collection)

This very beautiful ewer and basin, with gilt-bronze mounts, was
probably used for washing the hands between courses at the dining-table.
The ground colour of *bleu céleste* was first introduced by Jean Hellot at
Vincennes in about 1752. It was almost certainly inspired by the
turquoise enamel seen on Chinese porcelain of the K'ang Hsi period
(1662–1722). Paler shades of turquoise were used at the factory at a
slightly later date, but these hues do not appear to have been referred to
in the records by any different name. Similar shaped ewers can be seen in
both the Wallace Collection and the Victoria and Albert Museum (Jones
Collection). The letters 'PY', flanking the crossed 'L' device on this
example, might well be the mark of Jean-Jacques Pierre (*jeune*), who was
active as a painter of flowers from 1763–1800.

Plate 53

Ecuelle, cover and stand; soft-paste
porcelain, enamelled in colours
and gilt
Marks: crossed 'L's and 'LD'
incised
SEVRES (France); *c.*1775
Length (of tray) 8 ins.

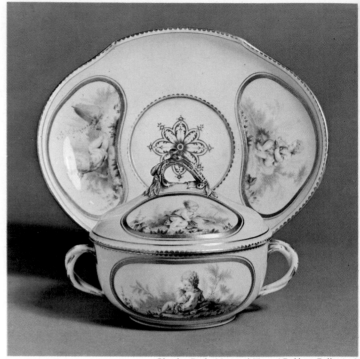

Clandon Park, National Trust (Gubbay Collection)

One of the most attractive of the Sèvres ground colours was the yellow
(*jaune*) introduced by Hellot in 1753. Early wares decorated in this colour
are extremely rare, but the factory records tell of pieces of this type being
made for Madame de Pompadour and the Duc d'Orléans. Wares with
this yellow ground were usually decorated with figures of children
painted in blue enamel with only the flesh tints in natural colours.

A ewer and basin in the Victoria and Albert Museum has the date-
letter for 1763 (K), and the mark of the painter Catrice, who was active at
the factory from 1757 to 1774. Figures were also painted in this same
palette by Vieillard (1752–90). The simple gilt frames to the reserved
panels on this example suggest the later date of about 1775, but there is
no mark to indicate the painter. The term *jaune jonquille* was apparently
not adopted until the 19th century, when wares of this type were
frequently reproduced.

Plate 54

Cup and saucer; soft-paste
porcelain, decorated in enamel
colours and gilt
Mark: crossed 'L's enclosing
letter 'U' (1773)
SEVRES (France); 1773
Diameter (of saucer) $5\frac{3}{4}$ ins.

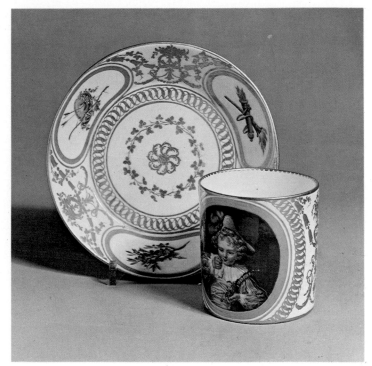

Clandon Park, National Trust (Gubbay Collection)

In 1759 the Sèvres factory was undergoing considerable financial
difficulties and, to save the factory from possible closure, Louis XV
bought out the remaining partners and became the sole proprietor,
running the factory as a royal concern. From this time those seeking
favours at Court were well advised to spend freely at the large annual sale
of Sèvres porcelain held at Versailles.

This very attractive cup and saucer was painted by Charles-Nicolas
Dodin, who worked at Vincennes and Sèvres as a painter from 1754 to
1802, one year before his death at the age of 69. Records concerning the
work of this decorator prove that he was a very industrious worker, who
attained the post of *premier peintre en miniature*, at a salary of 145 *livres* per
month. His painting of human figures was among the finest to be seen on
Sèvres porcelain and his portraits, such as this study of a child eating
cherries, were usually taken from the work of well-known masters, a
fashion in decoration that was very much in demand at the time. Dodin's
best-known work can be seen on the dessert-service made for Louis XVI,
which is now at Windsor Castle, in England. This cup-and-saucer is also
marked with 'LG' in gilt, the mark of Etienne Henry Le Guay, a very
long-serving gilder, who was engaged from 1748–49, and 1751–96.

Plate 55

Cup and saucer; soft-paste
porcelain decorated in enamel
colours and gilt
Marks: crossed 'L's enclosing
letter 'Z' (1777), numerals 119
and initials BD
SEVRES (France); 1777
Diameter (of saucer) $4\frac{1}{4}$ ins.

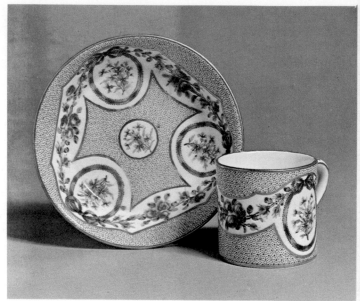

Clandon Park, National Trust (Gubbay Collection)

During their most prosperous years Sèvres porcelain was in great demand
by the various Paris dealers. The most famous of these was Lazare
Duvaux who, for a short time, was the sole distributor of their wares. His
advice was also sought concerning potential sales and the wares most
likely to prove popular.

Coloured cornflowers, as used to decorate this cup and saucer, were a
style much admired by Queen Marie Antoinette. The initials of the
painter, 'BD', are not shown in the various published lists, except under
Baudouin *père*, who is recorded as a gilder between 1750 and 1800, but
not as a painter. Unfortunately the 18th-century records are both few
and incomplete. Louis XVI, who succeeded his grandfather in 1774, was
too engrossed with more pressing affairs of state to be able to devote the
same attention to the running of the royal porcelain factory as Louis XV,
and from that time the factory began to decline.

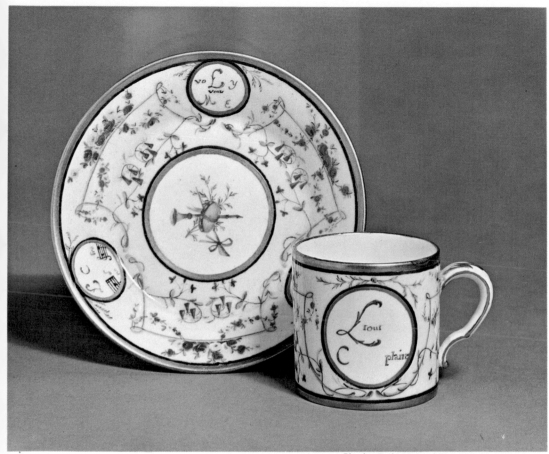

Clandon Park, National Trust (Gubbay Collection)

Plate 56

Cup and saucer; decorated in
enamel colours and gilt
Marks: crossed 'L's enclosing
date-letter for 1788, painter's
mark 'V' and gilder's mark 'F.M.'
SEVRES (France); 1788
Diameter (of saucer) 4⅜ ins.

In his excellent catalogue of the Waddesdon Collection of Sèvres
Porcelain (see Bibliography), Svend Eriksen sheds a great deal of new
light on this most important factory. We learn that cups of the form
shown have been produced from as early as 1752, when the production
was still at Vincennes, until the present day. The shape was referred to as
gobelets en litron or *tasses forme litron*, due to their 'similarity to the old
cubic measure called *litron*'. The shape was produced in a variety of sizes.

This rather late cup and saucer (1788, date-letter 'KK'), has some rather
unusual characteristics, for example, the pale yellow ground is
uncommon and it was not the usual practice to paint enamel decoration
of this type directly onto a coloured ground. The so-called 'amatory
ciphers' in the reserved panels will doubtless always have a secret
meaning, except to those for whom the piece was originally painted.
Neither the painter's, or gilder's marks can in this instance be associated
with any recorded Sèvres workers.

Plate 57

Cup and saucer; hard-paste
porcelain, decorated in enamel
colours and gilt
Mark: 'R.F.' monogram and
'L.S.' or 'L.F.'
SEVRES (France); c.1795
Diameter (of saucer) $5\frac{1}{2}$ ins.

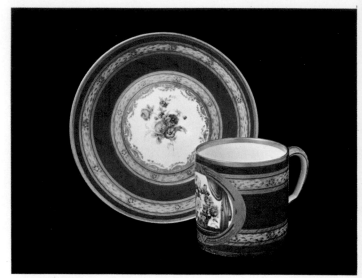

Private Collection

Although hard-paste porcelain, made entirely from French raw materials, was successfully produced at Sèvres in 1769, it was not used to any great degree until 1772, by which time other factories in Paris, Limoges and Lunéville, were making wares from similar material, despite various attempts by the royal factory to enforce their monopolies. Up to 1800 both types of porcelain were produced, but the manufacture of soft-paste was then halted as being too costly although it was used again for a short period from 1849. A further type of soft-paste was also used from 1907.

With the abolition of the monarchy the factory ceased to have any royal ties and was taken over by the First Republic, hence the newly adopted monogram mark of 'R.F' over 'Sèvres' in blue (*Republique Français*). There were very few new designs or styles introduced during this period (1783–1800), other than some interesting ground colours as illustrated on this cup and saucer. Napoleon was anxious that the former royal factory should continue in order to serve his own needs and in 1800 he appointed Alexandre Brongniart as the director. It was Brongniart who was responsible for the sales of great quantities of earlier, but outmoded stock, much of which unfortunately fell into the hands of both French and English decorators who through dealers launched onto the eager market many pieces of porcelain which they had decorated in the early and much sought-after styles. The coloured grounds of *rose* and *bleu céleste* and the gilding of the 19th century were invariably well below the standard of the 18th-century factory work.

Plate 58

Miniature ice-pail; soft-paste
porcelain, decorated in enamel
colours and gilt
TOURNAI (Belgium); *c.*1787
Height 2¾ ins.

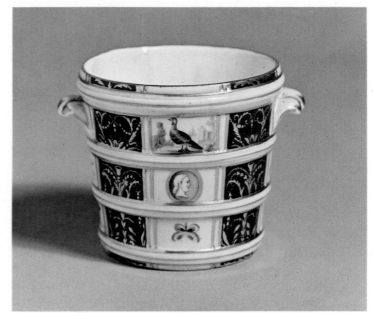

Clandon Park, National Trust (Gubbay Collection)

Although Tournai is now in Belgium their porcelain is usually associated
with that of France. Soft-paste porcelain was produced at Tournai from
1751 by F. J. Peterinck (*d.*1799), under whose direction the factory
continued until 1796. The undertaking was continued by his son until
1800, after which it passed, through the marriage of Peterinck's daughter,
to the Bettignies family, whose main claim to fame were their well
produced forgeries of French and English soft-paste porcelains, in the
18th-century fashions.

 This small ice-pail (or *cachepot*), is decorated in the best known of all
the Tournai patterns. This piece might well have formed part of the
original service, which was ordered in 1787 by Philippe, Duc d'Orléans.
The enamel bird-painting was taken from Buffon's *Natural History*,
published in the previous year, and is attributed to J. G. J. Mayer, who
was head painter at the factory from 1774. The style of decoration
proved so popular that it was almost certainly used at Tournai on many
other wares in addition to this documented service.

 During the third quarter of the 18th century some very attractive
groups of figures were modelled by Nicolas Lecreux, Antoine Gillis,
Nicolas Gauron and Joseph Willems. These figure subjects were rarely
marked and can well be confused with those of other French or English
soft-paste porcelain factories. The early and finer wares of Tournai were
sometimes marked with a sketch of a tower in either gold or coloured
enamel. The later more common mark consists of crossed swords with
crosses in the lower three angles.

Plate 59

Cup and tray; hard–paste porcelain, decorated in enamel colours and gilt
Mark: 'AG' monogram, in gold
RUE DE BONDY (Paris);
1781–93
Length (of tray) 7½ ins.

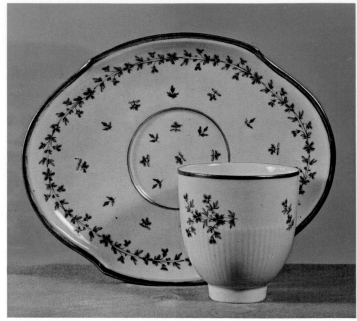

Victoria and Albert Museum

Following the discovery in France of the materials necessary for the manufacture of hard-paste porcelain, many new factories were set up within the area of Paris. Some of these concerns were protected from the harsh monopolies imposed by the Royal Sèvres factory through the interest of members of the Royal family. Clignacourt, established in 1771, was associated from 1775 with the King's brother, Monsieur, later King Louis XVIII. Rue Thiroux was protected by Queen Marie-Antoinette, and rue de Bondy was favoured by the Duc d'Angoulême, son of the Comte d'Artois. The cup and tray illustrated were made at this latter factory.

The rue de Bondy factory was founded in 1780 by Dihl and Guerhard, who produced large quantities of table-wares, some lavishly decorated in the current Sèvres fashions, others more tastefully and sparsely enamelled, often with the popular 'Angoulême sprig', as shown in the photograph. This style was adopted by many other French and English porcelain factories. The mark registered in 1781 consisted of an 'AG' monogram in blue, for Angoulême. A further mark stencilled in red was used from about 1780–93, which read 'MANUFRE/de MGR le Duc/d'angoulême/a Paris'. This form of mark was changed from the time of the Revolution to include the names of the proprietors, 'MANUFRE/de MM/Guerhard et/Dihl a Paris'. The factory closed in 1829.

Plate 60

Coffee-pot and cover; hard-paste porcelain, decorated in enamel colours and gilt
Mark: 'J.P' in underglaze-blue FONTAINEBLEAU (France); Jacob Petit's factory; c.1835
Height 10¾ ins.

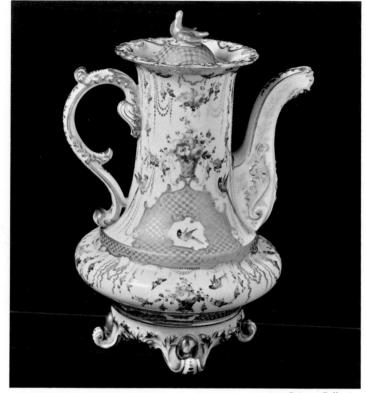

Private Collection

The wares made by the French potter Jacob Petit (d.1868) have often been the subject of wrong attributions as they are frequently so similar to pieces made at several different English porcelain factories. Fortunately, however, Petit used only a hard-paste porcelain, whereas the English wares of a similar type are usually of a bone-china. This potter was born in Paris in 1796, and adopted as a trade-name his wife's maiden name of Petit, in preference to his own name of Mardochée.

The production was started at Belleville in about 1830. The business flourished to such an extent that in 1834 further premises were acquired in Fountainbleau where Petit was soon producing not only table-wares but also highly decorated ornamental pieces, which warranted a warehouse in Paris and a total of over two-hundred workmen. Through various misfortunes he became bankrupt in 1848. The quality of the workmanship of his wares was very high, but the extravagant forms and decorations were thought to be a little too extreme, even for that period. His range of wares included entire mantlepiece garnitures, flower-stands, the numerous frivolities of the mid-19th-century dressing-table, *veilleuses*, and vessels in the form of figures, often embellished with relief flowers, and made to serve a variety of purposes. This versatile potter also produced a range of biscuit porcelain figures, often using the earlier German technique of dipping real lace into porcelain paste in order to achieve the effect of lace on the garments.

The normal mark is 'J.P.' in high-temperature blue, but these initials do not necessarily signify his work, as Jaquemin, one of his former employees, later acquired all the Petit material. In addition Petit sold undecorated wares to both decorators and dealers, a practice which often resulted in there being pieces with dual marks; those of both Petit and the later decorator.

73

Plate 61

Jug; hard-paste porcelain,
decorated in enamel colours and
gilt
Probably PARIS (France); *c.*1835
Height 9⅞ ins.

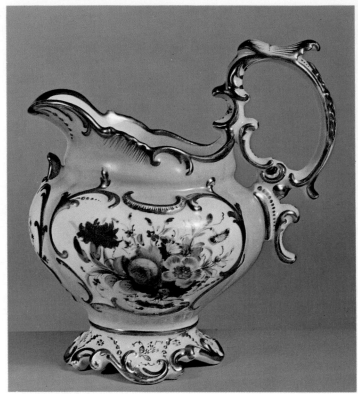

Victoria and Albert Museum

The new collector will be pleased to learn that even those with many
years' experience, do at times have difficulty in determining whether a
piece of porcelain is of hard-paste or soft-paste. This, in turn, can often
mean deciding whether a piece is genuine, or a later reproduction, and is
often the case with some English porcelain figures, of 18th-century date,
which were so frequently imitated on the Continent during the second
half of the 19th century.

It was during the early years of the 19th century that many styles of
decoration were equally popular in England and France and this is
particularly noticeable with the so-called 'revived rococo', as illustrated
here. In this instance it is because this jug is hard-paste porcelain, that one
can confidently say it is French, and not by one of the many English
manufacturers of the same period, who by 1830 would have been using
the more popular body of bone-china, as introduced by Josiah Spode in
1800. Unfortunately wares of this type, whether French or English, are
only rarely found with factory-marks.

MARKS

Italy

FLORENCE. Medici soft-paste porcelain; 1575–c.87. Dome of the cathedral of Florence in underglaze-blue.

VENICE. Hard-paste porcelain of Vezzi; c.1720–27. Underglaze-blue, red, blue enamel, or gilt.

VENICE. Hybrid porcelain of hard-paste type, Cozzi; c.1764–1812. Red enamel or gilt.

DOCCIA. Hard-paste porcelain of Ginori; 1735 – present (Richard-Ginori). Six-pointed star in blue, red, gilt or impressed, late-18th to first half of 19th century.

LE NOVE. Hard-paste porcelain; 1762–1825. Mark in gold, used after 1781.

CAPODIMONTE. Soft-paste porcelain; 1743–59. Fleur-de-lys mark, impressed, in gold or blue.

NAPLES. Soft-paste porcelain; 1771–1806. 'F.R.F.' for 'Fabbrica Reale Ferdinandea' in red, blue, purple. Crowned 'N' used in blue, red or impressed from c.1787.

Spain

BUEN RETIRO. Soft-paste porcelain; 1760–1808. The same fleur-de-lys as on Capodimonte wares. This Madrid mark, in red enamel, was used from 1804–8.

Germany

MEISSEN. Hard-paste porcelain; 1710 to present. 'Crossed swords' introduced in c.1723, in underglaze-blue, except on some wares decorated in Japanese style, when mark is in blue enamel.

MEISSEN. Later form of 'crossed swords' mark of the so-called Marcolini Period; 1774–1814.

MEISSEN. The monogram mark of Augustus Rex, Elector of Saxony, King of Poland (d.1731). This mark was imitated by minor German factories and decorators from the second half of the 19th century.

HÖCHST. Hard-paste porcelain; c.1750–1796. 'Wheel-mark', incised, impressed, in blue or coloured enamels.

FÜRSTENBERG. Hard-paste porcelain; 1755 to present. 'F' mark used in various styles in underglaze-blue.

W

BERLIN. Hard-paste porcelain, Wegely period; 1750–57. 'W' in underglaze-blue. (See also Wallendorf.)

BERLIN. Hard-paste porcelain, Gotzkowski's factory; 1761–63. 'G' in underglaze-blue.

BERLIN. Hard-paste porcelain. State period; 1763 to present. Sceptre mark in underglaze-blue.

NYMPHENBURG. Hard-paste porcelain; 1755–1810 (also used in present Nymphenburg factory mark). Impressed, sometimes with 'hexagram' mark in underglaze-blue.

FRANKENTHAL. Hard-paste porcelain; 1755–59. Lion mark in underglaze-blue, with 'PH' for Paul Hannong (1755–59) impressed.

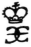

FRANKENTHAL. Hard-paste porcelain; 1762–1795. 'CT' for Carl Theodor in underglaze-blue.

LUDWIGSBURG. Hard-paste porcelain; 1759–90. Mark in underglaze-blue, or red enamel.

FULDA. Hard-paste porcelain; 1764–90. 'Furstlich-Fuldaisch' mark in underglaze-blue, 1780–88.

VOLKSTEDT. Hard-paste porcelain; 1760–99. 'Crossed forks' or single fork, in underglaze-blue.

WALLENDORF. Hard-paste porcelain; 1764 to 19th century. Early mark in underglaze-blue, drawn to imitate Meissen crossed swords.

POTSCHAPPEL (Dresden). Hard-paste porcelain; 1875 to present. One example of the many marks by Carl Thieme.

Austria

VIENNA. Hard-paste porcelain; 1717–1864. Shield mark introduced in 1744, in blue or impressed.

Holland

M.O.L

OUDE LOOSDRECHT. Hard-paste porcelain; 1771–84. Mark of Johannes de Mol in underglaze-blue or enamel colour.

WEESP. Hard-paste porcelain; 1759–71. In underglaze-blue.

THE HAGUE. Hard-paste porcelain; c.1766–90. 'Stork' mark in underglaze-blue or blue enamel.

Belgium

TOURNAI. Hard-paste porcelain; 1751 to 19th century. Mark of F. J. Peterinck 1751–96, in enamel or gilt.

Denmark

COPENHAGEN. Hard-paste porcelain; 1771 to present. 'Wave-mark' in underglaze-blue, 1775 to present.

Russia

ST. PETERSBURG (*now* Leningrad). Hard-paste porcelain; 1744–1917, when the factory was taken over by the State. Underglaze-blue mark of Catherine II, 1762–1796.

MOSCOW. Hard-paste porcelain; c.1765 to present. Mark of Francis Gardner, c.1765–1891.

France

SAINT-CLOUD. Soft-paste porcelain; c.1690–1766. 'Sun face' mark in underglaze-blue.

SAINT-CLOUD. Soft-paste porcelain, mark of Henri Trou management; c.1722–1766. In underglaze-blue.

CHANTILLY. Soft-paste porcelain; 1725–c.1800. 'Hunting horn' mark, usually in red enamel to c.1740, then in underglaze-blue or enamel colour.

D·V·

MENNECY. Soft-paste porcelain; 1734–1806. 'D.V' for Duc de Villeroy, in red, blue, or incised.

VINCENNES. Soft-paste porcelain; 1738–1756. Royal cypher mark in blue enamel used from c.1738.

SEVRES. Soft-paste porcelain up until c.1772, then both materials in use until

about 1800. 1756–1793 as Royal Factory. Cypher mark with date letter 'B' for 1754.

SEVRES. Hard-paste porcelain and small quantity of soft-paste. Mark of French Republic (1793–1804) in blue enamel.

PARIS (Clignacourt). Hard-paste porcelain; 1771–c.1798. Registered mark of 1771–1775 in gold.

PARIS (rue Thiroux). Hard-paste porcelain; c.1775 to 19th century. Crowned 'A' for Queen Marie-Antoinette, protector of factory until 1793, in red enamel.

PARIS (rue de Bondy). Hard-paste porcelain; 1780–1829. Mark of protector, the Duc d'Angoulême, c.1780–1793, in gold.

PARIS (La Courtille). Hard-paste porcelain; 1771–c.1840. 'Arrow' mark in imitation of that of Meissen, in blue, or incised.

LILLE. Hard-paste porcelain; 1784–1817. Mark of the Dauphin, the protector of the factory, stencilled in red enamel.

JP

FONTAINEBLEAU. Hard-paste porcelain, 1795 to present. Mark of Jacob and Mardochée Petit, 1830–1862, in underglaze-blue, or incised.

GLOSSARY

ALKALINE GLAZE	a glaze, composed of soda or potash and sand, used on a clay body which also includes the same elements
ARCANIST	an alchemist possessing the knowledge (or arcanum) of the manufacture of porcelain
BISCUIT	a term used to describe a once-fired ceramic body without glaze
BOCAGE	a screen of leaves and flowers used as a background to a figure or group
BODY	an alternative name to describe a type of ceramic ware
camaieu	decoration painted in various tones of a single colour (monochrome)
CHINA-CLAY	a white refractory clay formed, over a long period, from decomposed granite
CHINA-STONE	a fusible stone which when fired at about 1350°C, together with china-clay, forms the hard, white, translucent material of hard-paste porcelain
CRAZING	a fault in the glaze resulting in minute surface cracks. The larger 'crackle' sometimes seen on Far Eastern wares, was deliberately caused to give an appearance of antiquity
Deutsche Blumen	naturalistic enamel flower painting as introduced at Meissen in about 1740
ENAMEL	a form of coloured glass used to decorate ceramics by fusing to the glaze at a temperature not exceeding 800°C
famille jaune	a style of decorating Chinese porcelain with a palette of enamel colours dominated by yellow, which was often used as a ground colour
famille noire	a style of Chinese porcelain decoration where black enamel is used as a ground colour. Wares of this type have been reproduced during the 19th century in France
famille rose	a style of Chinese porcelain decoration used from the early-18th century. 'Rose' refers to the shades of pink to crimson enamel derived from chloride of gold
famille verte	the enamel palette introduced in China during the reign of the Emperor K'ang Hsi (1662–1722), in which the dominating colours are varying tones of green
FELDSPATHIC GLAZE	a glaze rich in felspar (alumino silicates)
fleurs des Indes	Oriental type flower painting, usually with a black outline. Chinese porcelain was frequently misnamed Indian, due to their being imported to Europe by the ships of the East India Companies
FRIT	a powdered form of the ingredients of glass, used in soft-paste porcelain as an alternative to china-stone
GALENA	a lead sulphide used for early lead glazes
GILDING	the application of various forms of gold to the surface of wares. Early gilding consisted of ground gold leaf or gold powder, with honey as a medium. This was applied in liquid form and then fired on to the glazed ware. From the late-18th century the honey was replaced by an amalgam of mercury and then fired. After firing the gilding was burnished
GLOST-KILN	the type of kiln used to fuse the glaze to a ceramic ware
grand feu COLOURS	the limited range of colours that can be fired at the same temperature as the glaze. This range of colours was extended from the early-19th century by the use of chrome

HARD-PASTE PORCELAIN	the type of porcelain first introduced in China from about AD 850, made from china-clay and china-stone
'INDIA FLOWERS'	see *fleurs des Indes*
KAOLIN	the Chinese term for china-clay, meaning 'high-ridge'
LEATHER-HARD	the term used to refer to the condition of the clay after being formed into shape, but still with a moisture content
LUSTRE DECORATION	metallic colours fused to the surface of wares in a reduction kiln, copper resulting in copper-coloured tones; silver firing to a brassy yellow; chloride of gold looking like copper when applied to a dark brown body, and appearing as pink when on a white surface. Platinum was used to give the effect of silver, this does not oxidise to a black as real silver would
LUTING	the use of liquid clay, or slip, to either assemble the various parts of a moulded figure or to apply separately moulded decoration to the surface
MOULDING	the shaping of clay by using prepared moulds. The clay is used in a plastic state and hand pressed into the hollow moulds
MUFFLE KILN	low-firing kiln (about 800°C) used to apply enamel colours to ceramics
OXIDISING KILN	a kiln into which air is freely admitted, the kiln atmosphere resulting in different tones of colour on the wares or decoration
'PARIAN' WARE	a white ceramic body introduced about 1840, used primarily for the scaled-down reproductions of full-size sculpture. It was also used, normally with a glaze, for decorative and table-wares
petit feu COLOURS	the large range of enamel colours fired at a low temperature of *c.* 800°C
PETUNTSE	the Chinese term for the china-stone after it has been prepared for the potter, meaning 'little white bricks'
REPAIRER	the name given to the workman who assembles the various moulded, or cast, sections of a figure or vessel, with the aid of slip
REDUCTION KILN	a kiln where a smoky atmosphere is deliberately caused to achieve certain effects and colours to the wares being fired
SLIP-CASTING	the forming of clay wares, or figures by pouring slip into hollow plaster-of-Paris moulds. The plaster absorbs the water and in doing so builds up a layer of clay on to the inside wall of the mould. When sufficient thickness of clay has been obtained the surplus slip is poured off, and after a short interval the cast may be removed from the mould
SLIP	clay watered down to a creamy consistency
SOFT-PASTE PORCELAIN	artificial porcelain made from white-firing clays and the ingredients of glass, bone-ash, steatite, etc.
SPRIGGING	the application of separately moulded decoration to the surface of wares, such as on salt-glazed stoneware or 'Astbury'-type pottery
THROWING	the process of forming a hollow circular form from clay by hand, with the use of a fast-turning potters' wheel
TRANSFER PRINTING	the transferring of a design engraved into a copper-plate, or wood-block, by means of a thin paper, or slab of gelatine, onto the surface of the body, or glaze, of a ceramic ware. High temperature colours are applied prior to glazing, low temperature colours are fused onto the glazed surface. This same process was used on enamel wares (enamel on metal base)
WASTERS	faulty wares, now usually sought as evidence of manufacture on the sites of former potteries

BIBLIOGRAPHY

VERLET, PIERRE, *Sèvres, Le XVIIIe Siecle*, Paris, 1953

LANE, A. E., *Italian Porcelain*, Faber & Faber, 1956

HACKENBROCK, YVONNE, *Meissen & other Continental Porcelain in the Irwin Untermeyer Collection; NY.*, Oldbourne Press, 1956

DUCRET, S., *German Porcelain & Faince*, Thames & Hudson, 1962

CHARLES, R., *Continental Porcelain*, Benn, 1964

MEISSEN STATE PORCELAIN FACTORY, *Catalogue of Porcelain Figures*, 1966

CHARLESTON, R. (Ed.), *World Ceramics*, Hamlyn, 1968

ERIKSEN, S., *Sèvres Porcelain (Waddesdon Manor)*, Office du Livre, Fribourg, 1968

ROSS, MARVIN C., *Russian Porcelain*, University of Oklahoma, 1968

DAUTERMAN, C. C., *Sèvres*, Studio Vista, 1969

DAUTERMAN, C. C., *The Wrightsman Colln.* Vol. IV., Metropolitan Museum NY., 1970

CUSHION, J. P., *Pottery & Porcelain Tablewares*, Studio Vista, 1972

HONEY, W. B., *French Porcelain of the 18th Century*, Faber & Faber, 1972

HONEY, W. B., *Dresden China*, Faber & Faber, 1972

SCHNEIDER, Dr. E., *Catalogue of the Collection in the Schloss Lustheim, Bavaria*, 1972

WALCHA, O., *Meissner Porcelain*, Dresden, 1973

CUSHION, J. P., *Handbook of Pottery & Porcelain Marks*, Faber & Faber, 1980